lighting | for interiors
photography

John Freeman

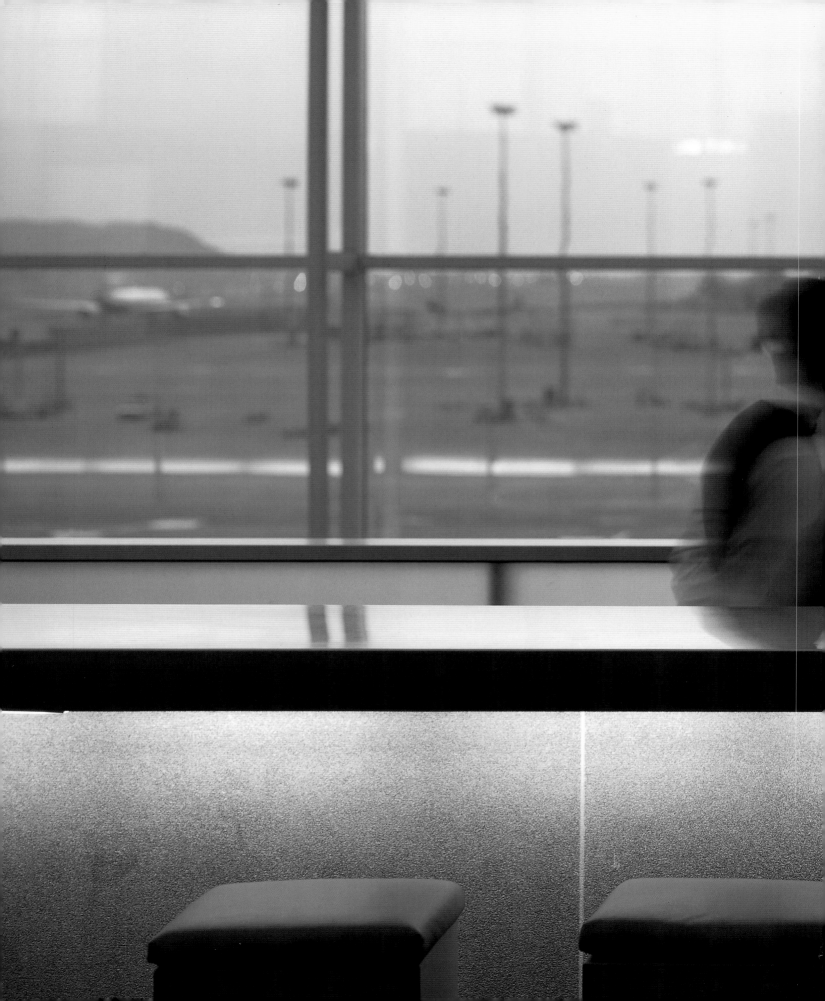

lighting | for interiors
photography

John Freeman

A RotoVision Book.
Published and distributed by
RotoVision SA, Route Suisse 9
CH-1295 Mies
Switzerland

RotoVision SA, Sales, Production & Editorial Office
Sheridan House, 112–116A Western Road
Hove, East Sussex BN3 1DD, UK

Tel: +44 (0) 1273 72 72 68
Fax: +44 (0) 1273 72 72 69
E-mail: sales@rotovison.com
Website: www.rotovision.com

ISBN 2–88046–671-7

10 9 8 7 6 5 4 3 2 1

Book design by Red Design
Illustrations by Robert Brandt

Originated by Hong Kong Scanner Arts
Printed and bound in China by Midas Printing

Front cover: Red staircase by Martine Hamilton Knight/Arcaid.co.uk
Page 1: The Hempel Hotel by Andreas von Einsiedel
Pages 2 & 3: Cathay Pacific Lounge by Dennis Gilbert/View

Richard Bryant/Arcaid.co.uk

contents

lighting...

Whether you developed your photographic lighting skills by going to college, watching master photographers at work, reading books and magazines, or simply through trial and error, you will by now have built up a solid repertoire of techniques that you come back to time and again. But endlessly recycling your set-ups quickly becomes boring and repetitive – not only for you, but also for your clients. What's more, styles of lighting change over time, and without realising it you can suddenly find your work looking dated – and neither successful nor saleable. As lighting is arguably the single most important element in any photograph, it's essential to keep up with contemporary trends.

That's where the RotoVision's LIGHTING... series comes in. Each title features a selection of cutting-edge images from leading exponents in that particular field, who have been persuaded to share their lighting secrets with the world at large. In most cases, we have talked to the photographer at length to find out exactly where everything was positioned and why one kind of accessory was used rather than another. We also included useful general hints and tips.

Some of the images rely solely upon daylight; in others, ambient illumination is combined with flash or tungsten lighting; and some feature advanced multi-head arrangements. As a result the LIGHTING... series provides a wonderfully rich smorgasbord of information which would be impossible for you to get any other way. It's like standing next to some of the world's most successful image-makers and watching them at work. Each self-contained double-page spread focuses on an individual shoot or looks at the approach of a particular photographer in more depth.

Three-dimensional lighting diagrams show you the set-up at a glance while the commentary explains in detail what was involved. Whenever possible, we have also included additional images that were either taken at the same time or using the same technique, or illustrating an alternative treatment.

Who will find this book useful? Anyone looking to improve their photography, whether it be for pleasure or profit. Professionals, or anyone looking to make the move from amateur to professional, will find it an invaluable source of inspiration to spice up their own image-making. It doesn't matter how much experience we have as photographers – there's always something new to learn. Any of the photographs here could help kick-start the engine of your imagination and get your creative juices flowing in a different and more interesting direction.

Alternatively, you may be looking to solve a particular picture-taking problem. You've got a job to do and you're not sure what would be the best approach. Or you've run short of ideas and want to try out some new techniques. If so, simply flip through the pages until you come across an image that has the kind of feel or look you're after and then find out how it was created.

Art directors, too, will find each title an invaluable primer on contemporary styles as well as a source for new photographic talent. Ultimately, though, LIGHTING... will appeal to anyone who enjoys looking at great pictures.

7

...for interiors

photography

Cities, towns and villages are the natural habitat of the human race. Ever since we evolved from caves and other makeshift shelters, we have tended to build our homes and working environments in clusters, which really are the remaining vestiges of the tribal instinct. As we grew richer and technology advanced, the spaces that we live, work or worship in, became more opulent and idiosyncratic. The majority of people sleep, eat and work indoors. It is therefore not surprising, that, for the photographer, interiors are such a rich source of inspiration for creative imagery.

It is not until one steps back and really thinks of the built environment, that we start to categorise the different types of interiors that surround us. The earliest types of man-made interiors that still exist are religious. These range from small Saxon churches, often stripped bare and low lit, to expansive cathedrals with a wealth of detail, both in architectural and interior design. Large country houses are another source of historic interiors, together with the houses and cottages that accommodated the population that worked in them. However, as these workers started to leave the land and seek employment in the fast growing industrial cities, different types of buildings were needed both for work and living. As these evolved and the wealth of the people increased, other buildings were constructed for leisure and entertainment.

With the advent of photography, recording these buildings and their interiors has proved a challenge for photographers through successive generations. Many of the pioneers of interior photography shot on black and white film with plate cameras, using long exposures, sometimes thirty minutes or more, to record an image. Later, with the advent of the flash, photographers would literally paint the interiors they photographed with flash, keeping the shutter open and directing multiple flashes into deep areas of shadow. Nowadays the vogue is for completely natural day lit shots with the appearance of sun-drenched rooms.

markets for interior photography

Home and lifestyle magazines specializing in interior design have seen phenomenal growth over the last decade. Television has played its part in this, with programmes being broadcast virtually on a daily basis. Like all other areas of the media, however, fashions change and what can seem a great interior today can look dated in just a matter of months. The same is true of lighting for interior photography. The trend of late, is for photographs of interiors to be almost entirely lit by natural light, with just a single flash head or reflector used as a fill. This is not necessarily the choice of individual photographers but rather the constraints imposed by editors and art directors who

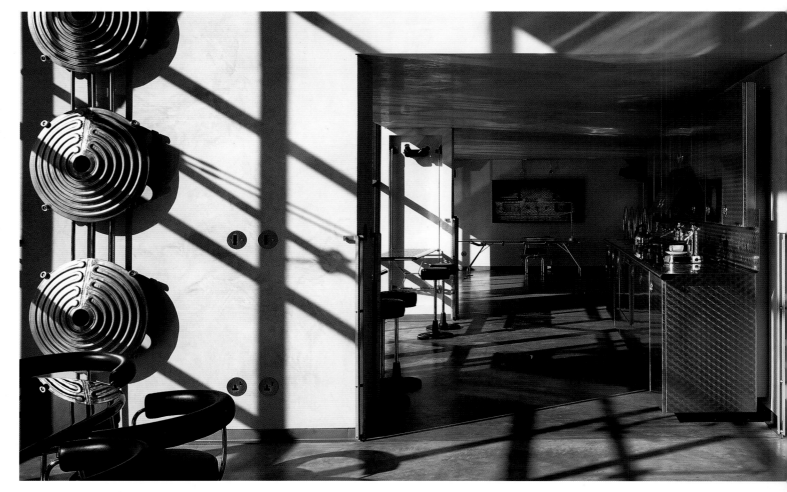

Richard Bryant/Arcaid.co.uk

want more shots per day and therefore, elaborate lighting set-ups are time consuming and uneconomic.

Depending on whether the shoot is commissioned or whether you find and originate a picture series yourself, there are bound to be overs that are not published. These, along with others that you own the copyright to, can be sold as stock photography. Many photographers, who work exclusively shooting interiors, have their own libraries or supply stock agencies that then sell their work on commission. Many magazines, even if they have commissioned the original shoot, pay the photographer additional money each time the shots are published. With overseas sales, this can boost the income from a single shoot quite considerably.

Books are another market that the photographer might want to consider. The photography for many architectural books is sourced from stock although it can sometimes be commissioned. Often an experienced interior photographer will approach a publisher with an idea and will already have a certain amount of material to back it up. Such a book may concentrate on a specific area of interior design such as curtains or paint effects or a particular architect or style.

developing a style

There are many ways of shooting an interior, as glancing through the plethora of current magazines will show you. Some photographers favour pure daylight, which might cause areas of the room to be burnt out, while others prefer to light the room, balancing any available light with their own. Aside from the room itself, there are details to be considered: a vase, a section of architrave or cornice, a section of a piece of furniture etc. Recently, there has been a trend to include figures in domestic room settings. These are often shot with lots of action so that the people appear blurred. Many magazines are strongly in favour of their photographers capturing as many of these "filler shots" as possible, as they add strength and individuality to the overall layout.

Once the style of lighting has been established there is also the area of sharp focus to consider. While many photographers may do an overall shot of the room in sharp focus, there is a trend to just focus on one aspect, and using a shallow depth of field lets a great deal of the shot fall off. This is particularly true when photographing details within a room.

lighting considerations

Having chosen your viewpoint and composed the shot, the question of lighting needs to be addressed. If you are using solely daylight, then you will have to consider the time of day you are shooting at carefully. The quality of early morning and late afternoon light will be far warmer than that of midday, and create a reddish cast. Moreover, as the sun will be lower at these times, shadows will be longer and harsher. If you are shooting towards a window, will you use fill-in flash or reflectors to record those areas that are in shadow, or will you let the window burn out therefore losing detail? Will tungsten lights need to be gelled to balance them to daylight or will you be using tungsten-balanced film? If this is the case, then any daylight that is in the shot will have a blue cast. If there is a great deal of fluorescent light, will you have the appropriate filter to take out what would be an otherwise green cast? Remember, that in this case any daylight coming into the room will record with a purple cast. If, in either of these cases more light needs to be added, will you have the appropriate gel for your flashlights to obtain the correct balance? All these issues and many more need to be considered before taking your shot.

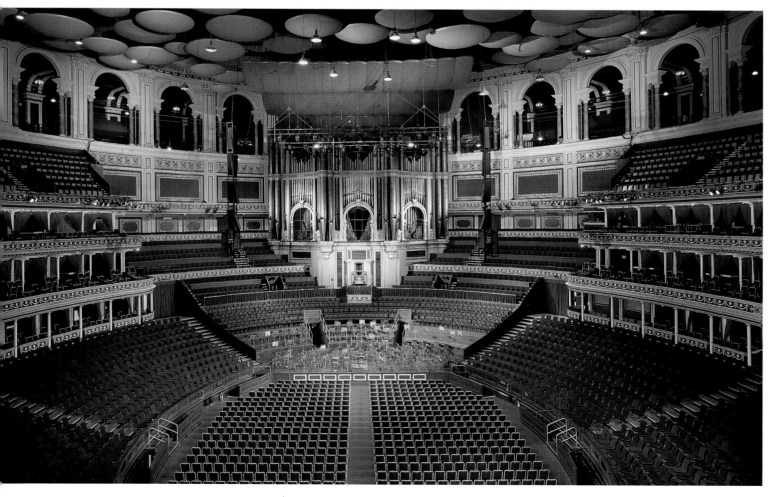

9

John Freeman

making light work
understanding light

Every art or business has its raw material: to create a pot requires clay, to carve a statue requires stone, and to produce a painting requires watercolours.

The raw material for photography is, of course, light. You can have all the cameras, lenses, accessories and film in the world, but without light you won't get very far.

And in the same way that other artists have to fashion their raw material, so photographers have to learn to work with light if they're to be successful. Indeed, as many of you will know, the very word "photography" derives from the Greek and means "painting with light" – still an excellent way of describing what it is we do.

The most astonishing thing about light is its sheer diversity – sometimes harsh, sometimes soft, sometimes neutral, sometimes plentiful, sometimes in short supply.

But given that light is the single most important element in any photograph, it's astonishing how few photographers pay any real attention to it. Many – even professionals! – can be so eager to press the shutter release and get the shot in the bag they don't pay it the attention it deserves. But for successful photography, an understanding of light, and the ability to use it creatively, are absolutely essential.

The best way of developing and deepening that understanding, is to pay close attention to the many moods of daylight. You might find yourself noticing how beautiful the light on the shady side of a building is, coming in through a small window, or dappled by the foliage of a tree, and use that awareness and knowledge when creating your own lighting setups.

quality vs quantity

Taking pictures is easier when there's lots of light. You're free to choose whatever combination of shutter speed and aperture you like, without having to worry about camera-shake or subject movement – and you can always reduce it with a Neutral Density filter if there's too much. But don't for a minute confuse quantity with quality.

The blinding light you find outdoors at noon on a sunny day, or bursting out of a bare studio head, may be intense, but it's far from ideal for most kinds of photography.

More evocative results are generally achieved when the light is modified in some way, with overall levels often much lower. With daylight, this modification may occur by means of choosing to shoot early morning or late evening, as these times of day are more atmospheric, or by shooting in different weather conditions to produce very different effects. Some of the most dramatic lighting occurs when opposing forces come together – such as a shaft of sunlight breaking through heavy cloud after a storm.

soft and hard

In some situations and for some subjects you will want light that is hard and contrasty, with strong, distinct shadows and crisp, sharp highlights. Outdoors when it's sunny, the shadows are darker and shorter around noon and softer and longer when it's earlier and later in the day.

Contrasty lighting can result in strong, vivid images with rich, saturated tones if colour film has been used.

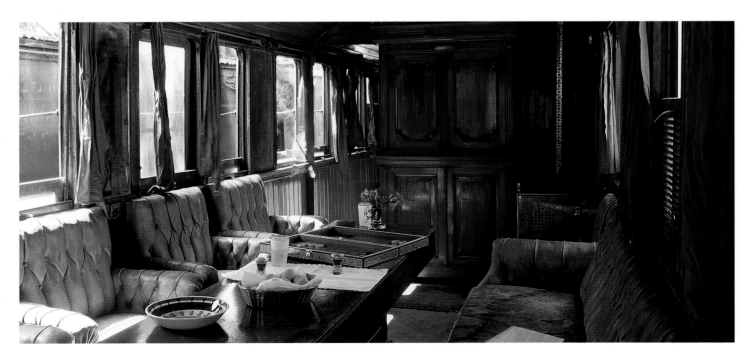

Tim Beddow

However, the long tonal range you get in such conditions can be difficult to capture on film, especially when using transparency materials, and you may have to allow either the highlights to burn out slightly or the shadows to block up. Care must be taken when doing so that no important detail is lost or that the image doesn't then look either too washed out or too heavy. If so, some reduction in contrast can often be achieved by using reflectors.

This kind of contrasty treatment is not always appropriate or suitable, though, and for many subjects and situations a light with a more limited tonal range that gives softer results may work better. Where you want to show the maximum amount of detail, or create a mood of lightness and airiness with the minimum of shadows, the soft lighting of an overcast day or a large softbox is unbeatable.

Here the principal risk is that the picture will be too flat to hold the viewer's interest – though imaginative design and composition should avoid that problem.

lighting direction

In every picture you take, you are using light to reveal something about the subject – its texture, form, shape, weight, colour or even translucency. That's where, to a large degree, the direction of the lighting comes in. Looking at what you are going to photograph, and thinking about what you want to convey about it, will give you some idea about the best lighting direction to employ.

colour temperature

We generally think of light as being neutral or white, but in fact it can vary considerably in colour – you need only think about the orange of a sunrise or the blue in the sky just before night sets in. The colour of light is measured in what are known as Kelvins (k), and the range of possible light colours makes up what is known as the Kelvin scale. Standard daylight-balanced film is designed to be used in noon sunlight, which typically has a temperature of 5500k – the same as electronic flash. However, if you use daylight film in light of a lower colour temperature you'll get a warm, orange colour, while if you use it in light of a higher temperature, you'll get a cool, blue tonality. Such casts are generally regarded as wrong, but if used intentionally can give a shot more character than the blandness of a clean white light – as many excellent shots in this book demonstrate most eloquently.

John Freeman

making light work

understanding light

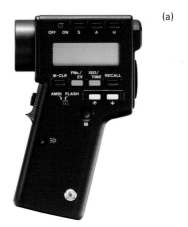

(a)

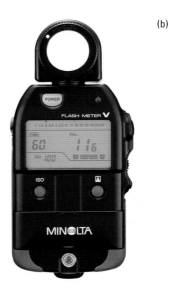

(b)

(c)

in-camera meters

Over recent years the accuracy of in-camera meters has advanced enormously and many autofocus models now boast computerised multi-pattern systems whose processing power would have filled the average lounge in the 1960s. By talking separate readings from several parts of an interior, and analysing them against data drawn from hundreds of different photographic situations, they deliver a far higher percentage of successful pictures than ever before.

However, the principal problem with any kind of built-in meter remains the fact that it measures the light reflected back from the subject – so no matter how sophisticated it may be it's prone to problems in tricky lighting situations, such as severe backlighting or strong sidelighting.

An additional complication is that integral meters are stupid – in the sense that they don't know what you're trying to do creatively. So while you might prefer to give a little more exposure to make sure the shadows have plenty of detail when working with black & white negative, or reduce exposure by a fraction to boost saturation when shooting colour slides, your camera's meter will come up with a "correct" reading that produces bland results.

Of course, not all in-camera meters are that sophisticated. Many photographers still use old and serviceable models with simple centre-weighted systems that are easily misled in all sorts of situations.

For all these reasons, any self-respecting professional photographer or serious amateur should invest in a separate, hand-held lightmeter, which will give them full control over the exposure process – and 100% accuracy.

incident light meters

Hand-held meters provide you with the opportunity to do something your integral meter never could: take an "incident" reading of the light falling onto the subject. With a white "invercone" dome fitted over the sensor, all the light illuminating the scene is integrated, avoiding any difficulties caused by bright or dark areas in the picture.

Using an incident meter couldn't be easier. You simply point it toward the camera and press a button to take a reading. Most modern types are now digital and you just read the aperture/shutter speed off an LCD panel, sliding a switch to scroll through the various combinations available. With older dial types you read the setting from a scale.

When using filters, you can either take the reading first and then adjust the exposure by the filter factor if you know it, or hold the filter over the sensor when making a measurement.

To those who've grown to rely on automated in-camera systems, this may sound like a long-winded way of going about things. But in fact, once you've used a separate meter a few times you'll find it doesn't take much longer. And what does it matter if it takes a few seconds more to get a good result?

Most of the time, the exposure calculated by an incident meter can be relied upon, but there are a couple of situations where you might need to make some slight adjustments:

1 When the interior/portion of interior you're shooting is either much darker or lighter than normal to get good reproduction, you may need to increase exposure by 1/2 to 1 stop with dark subjects and decrease exposure by 1/2 to 1 stop with light subjects.

2 When contrast levels are extremely high, and beyond the film's ability to accommodate them, it's often necessary to give 1/2 or even 1 stop extra exposure to prevent the shadows blocking up.

spot meters (a)

Those seeking unparalleled control over exposure should consider buying a spot meter, which allows you to take a reading from just 1° of the picture area. Many photographers involved in all kinds of picture-taking swear by theirs and would be completely lost without it.

Spot meters are different from incident meters in that they have a viewfinder which you look through when measuring exposure. At the centre is a small circle that indicates the area from which the reading is made. Of course considerable care must be taken when choosing this area.

If you plan to measure the exposure from just one area, you need to make sure it's equivalent in tone to the 18% middle grey the meter expects. Grass is usually about right, as is dark stonework on a building. To be sure, it's a good idea to carry around a Kodak Grey Card, designed specifically to give average reflectance.

Another alternative is to take a "duplex" reading measuring the lightest and darkest parts of the scene and then taking an average. Most spot meters offer a facility which does this automatically.

In some pictures, it's the correct rendering of the light or dark tones that's important, and some spot meters feature clever Highlight and Shadow buttons that ensure they come out correctly.

reciprocity law failure

The ISO ratings that manufacturers give their film operates on the basis that they have the same sensitivity whatever the aperture or shutter speed combination: the exposure will be the same at

1/60sec and f/2 as at 1/4sec and f/8 as at 4 seconds and f/32. This is called the Reciprocity Law – but it's not infallible.

If the shutter speed is longer than about 1 second, or shorter than around 1/4000sec, the reciprocity law may no longer apply and cause underexposure. The way to correct this is to give the exposure an additional increase to compensate for the film's loss of sensitivity. However, films vary enormously in terms of their reciprocity characteristics, so you may need to experiment with your favourite emulsion if you do a lot of long exposure work.

As a starting point, increase exposure by 0.5 stops if the shutter speed is 1/4sec, by 1 stop if it's 16 seconds and by 2-3 stops if it's 1 minute – although many manufacturers warn against using such long speeds because of the danger of significant shifts. However, modern emulsions have become so good that it is only in extreme conditions that reciprocity failure will become a real problem.

exposure latitude

If film manufacturers have anything to say on the matter, one day soon you won't need to make exposure adjustments, no matter how much the camera's meter is misled. By steadily increasing the exposure latitude of films – that is the degree to which they can be under- or overexposed and still give good results – they plan to make it all but impossible to get a bad result.

It is claimed that modern print films have a latitude of 5 stops: 3 stops over and 2 stops under. Certainly on the overexposure front, the claims are justified. Pictures given 2 stops more than required are generally indistinguishable from those that received the right amount of light.

Underexposure can be more of a problem. Give 1 stop less than is required and the prints are generally still OK, but underexpose by 2 stops and you often get significantly inferior results.

With colour reversal film, though, it's a different story. The latitude is significantly less – rarely more that 1 stop – and with some films, such as Fujichrome Velvia, as little as 1/2 stop with critical subjects. This means careful exposure compensation is crucial when shooting trannies.

flash meters (b)

Many of the more expensive hand-held meters, both incident and spot, have a facility for measuring electronic flash as well. For those who don't feel the need for an ambient meter, separate, reasonably-priced, flash-only meters are available.

The benefit of having a meter that can measure flash is obvious. When you are photographing an interior and need additional flash light, it allows you to make changes to the position and power of lights and then quickly check the exposure required to give a balanced fill-in effect.

Incident flash meters are used in exactly the same way as when taking an ambient reading. The meter is placed in front of the subject, facing the camera and the flash fired. This can usually be done from the meter itself, by connecting it to the synchronisation cable and pressing a button. Increasingly, infrared triggers that fit into the camera hot shoe are used to fire the flash.

The flash facility on spot meters is particularly helpful for making sure that the important part of the picture is correctly exposed. When shooting a portrait, for instance, a close-up reading can be taken of the subject's face.

Another widely available feature allows you to compare flash and ambient readings; this is ideal for balancing flash with ambient light or mixing flash with tungsten.

Some of the more advanced flash meters can also total multiple flashes; this can be helpful if you need to fire a head several times to get a small aperture for maximum depth of field.

colour temperature meters (c)

Colour temperature meters are specialist pieces of equipment that are not essential, but most photographers would benefit from one. These do not measure the amount of light, but its colour.

The standard measure for the colour of light is Kelvins (K). Daylight film is balanced for use at 5500K, although the actual colour of daylight varies considerably. On an overcast day it can be higher, 6000-7000K, producing a blue cast, or in late afternoon 4000K, giving the print an orange tinge.

A simple press of a button on a colour meter can confirm the exact colour temperature and tell you what light balancing filter(s) would be required to correct it. It also works with tungsten lighting, and the most difficult type of light to work with, fluorescent, indicating the necessary colour correction filter(s) needed to produce a neutral print. You may need a colour meter if you work mainly with colour negative film, but, if you use transparency film where colour accuracy is essential, it can be a worthwhile investment.

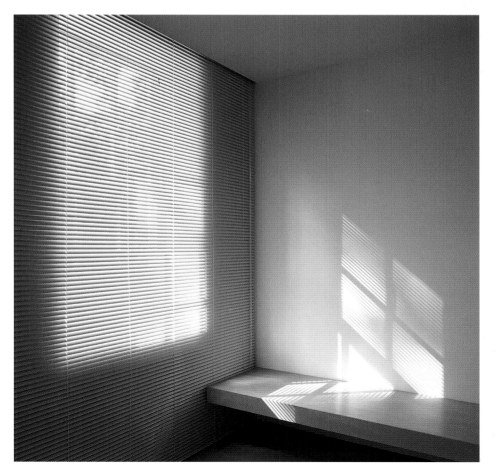

13

Richard Davies

making light work
using light

Some professionals – for certain kinds of work – like to shoot their interiors using daylight. Consider the advantages: the light you get is completely natural, unlike flash you can see exactly what you're getting and it costs nothing to buy or run.

Daylight can be controlled using large white and black boards which can be built around the subject to produce the effect required.

If the daylight is coming through north facing windows, or south facing in the southern hemisphere, it will be completely even. As no sun ever enters, the light remains constant throughout the day. It may be a little cool for colour work, giving your shots a bluish cast. If so, simply fit a pale orange colour correction filter over the lens to warm things up, an 81A or 81B should do fine.

Rooms facing in other directions will see changes of light colour, intensity and contrast throughout the day. When the sun shines in you'll get plenty of warm-toned light that will cast distinct shadows. With no sun, light levels will be lower, shadows softer and colour temperature more neutral.

The size of the windows in the room also determines how harsh or diffuse the light will be.

Having a room with at least one big window, such as a patio door, will make available a soft and even light. The effective size of the window can easily be reduced by means of curtains or black card, for a sharper, more focused light. In the same vein, light from small windows can be softened with net curtains or tracing paper. The ideal room would also feature a skylight, adding a soft downwards light.

Whatever subject you're shooting, you'll need a number of reflectors to help you make the most of your daylight, allowing you to bounce the light around and fill in shadow areas to control contrast.

using studio lights

Daylight has many merits, as the pictures in this book taken using ambient light, demonstrate. There are, however, also obvious disadvantages: you can't use daylight when the sun has gone, you can't turn the power up when you need more light and you don't have anywhere near the same degree of control you get when using studio heads.

Being able to place lights exactly where you want them, reduce or increase their output at will and modify the quality of the illumination according to

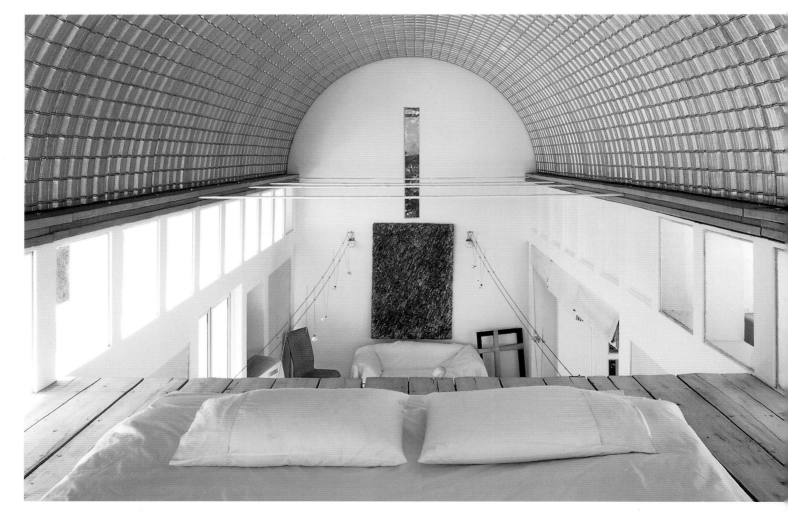

Jan Baldwin

your needs, means the only limitation to your work is your imagination. Any visualised lighting set-up is possible (although you might need to hire a few extra lights when you start to get more ambitious).

how many lights?

Some photographers seem to operate on the basis that 'the more lights the better', using every light at their disposal for every shot. In fact, there's a lot to be said for simplicity – there's only one sun, after all – and some of the best photographs are taken using just one perfectly positioned head. By using different modifying accessories you can alter the quality of its output according to your photographic needs. Before going onto more advanced set-ups, it's a good idea to learn to make the most of just a single light source. If you want to soften the light further and give the effect of having a second light of lower power, a simple white reflector is all you need.

Of course, having a second head does give you many more options: as well as using it for fill-in, you can place it alongside the main light, put it over the top of the subject, or wherever else works well.

Having two lights means you can also control the ratio between them, reducing or increasing their relative power to control the contrast in the picture. For many subjects a lighting ratio of 1:4 is ideal, but there are no hard-and-fast rules and experimentation often yields exciting and original results.

In practice, many photographers will need to have at least three or four heads in their armoury and unless advanced set-ups or enormous fire power are required, that should be sufficient for most situations.

However, it is worth reiterating that it is all too easy to overlight a subject, with unnatural and distracting shadows going in every direction. Before you introduce another light try asking yourself exactly what it will add to the image – and if it adds nothing, don't use it.

flash or tungsten?

The main choice when buying additional lighting is tungsten or flash, and there are advantages and disadvantages to both.

Tungsten units tend to be cheaper and have the advantage of running continuously, allowing you to see exactly how the light will fall in the finished picture. However, the light has a strong orange content, typically around 3400K, requiring the use of tungsten film or a blue correction filter used either over the lens or light for a neutral result. Tungsten lights can also generate enormous heat, making them unsuitable for certain subjects.

Flash heads are more commonly used because they are much cooler to run, produce a white light balanced to standard film stocks and have a greater light output. Again, it is a good idea to experiment with both.

which accessories?

Every bit as important as the lights themselves, are the accessories that are fitted to them. Very few pictures are taken with just the bare head, as the light simply goes everywhere – which is not normally the sought-after effect. To make the light more directional you can fit a dish reflector, which narrows the beam and allows you to restrict it to certain parts of your subject.

A more versatile option is provided by 'barn doors', which have four adjustable black flaps that can be opened out to accurately control the spill of the light. If you just want a narrow beam of light, try fitting a snoot, a conical black accessory which tapers to a concentrated circle.
Other useful accessories include spots and fresnels, which you can use to focus the light, and scrims and diffusers to reduce the harshness. If you want softer illumination, the light from a dish reflector can be bounced off a large white board or, more conveniently and especially for location work, fired into a special umbrella.

If that's not soft enough for you, invest in a softbox, a large white accessory that mimics window light and is perfect for a wide range of subjects. The bigger the softbox, the more diffuse the light.

using reflectors

Reflectors are simply flat sheets of reflective material designed to bounce light back onto the subject. The aim is to control the contrast within a scene by lightening, or 'filling-in', the shadow areas. Ready-to-buy reflectors come in all shapes and sizes, but many professionals prefer to improvise.

Folding circular types, using a clever 'twist and collapse' design, are easier to store and move around, and typically available in 30cm, 50cm, 1m or 1.2m diameter sizes. There are also 'professional' panels measuring around 6 x 4ft. Plain white reflectors are ideal when you want simple fill-lighting, while silver versions give a crisp, clear light and gold is ideal when you want to add some warmth.

Most of the time the reflector needs to be as close as possible to the subject, without actually appearing in the picture!

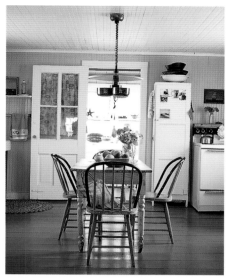

Jan Baldwin

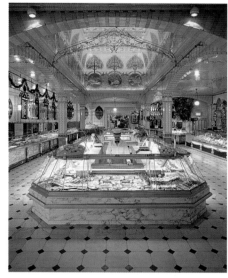

John Freeman

15

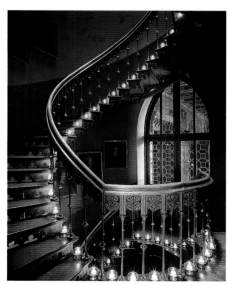

Fritz von der Schulenburg/Interior Archive

useful equipment

John Freeman

camera formats

The choice is wide when it comes to selecting the correct format for photographing interiors. It is not possible to say that one type of camera is better than another. Whether it is 5 x 4, medium format or 35mm, all have their plus and minus points, and it is only through experience that you will be able to establish which one is right for you and the brief.

For many years, 5 x 4 was the industry standard for architectural and interior photography. The facility for shifts, tilts and swings gave it an unrivalled ability for correcting converging verticals and increasing the area of sharp focus, rather than just relying on depth of field. The size of the negative or transparency meant that larger than average prints could be made without any discernable loss of definition and quality. Added to this, the vast range of different lenses and accessories that are available, and there was hardly a situation that could not be accommodated. Moreover, the satisfaction of looking at a correctly exposed and beautifully composed 5 x 4 transparency on a light box takes a lot of beating.

However, many photographers find its size, weight, slowness and the necessity to always use a tripod, a distinct disadvantage. Having to load dark slides with film, either beforehand in the darkroom, or in a changing bag when on site is another drawback. Many cannot get used to the fact that the image has to be viewed on a ground glass screen and is upside down and the wrong way round, although there are attachments on some models that correct this. Because of this, many prefer the versatility of the modern medium format camera. The most popular of these come in three different formats: 6 x 4.5, 6 x 6 and 6 x 7. The latter has the ability, on some models, to combine all three formats by using different film backs. The range of lenses available for these cameras has increased enormously over the years. Even lenses with shift and tilt facilities are now available. Different viewfinders, such as eye-level or waist-level, increase their versatility even further and some of these have built-in metering features. Different film backs, not just of varying format sizes, mean that a variety of films can be used. This enables the photographer to change from black and white to colour, daylight balanced film to tungsten, even in mid-roll. Polaroid backs enable you to check composition, exposure and lighting prior to the shot being taken.

Like medium format cameras, 35mm models have also become increasingly popular. While many purists will rubbish these as nothing more than snapshot cameras, they do have a place in modern interior photography. For a start they are light and compact. The range of lenses are second to none. Even Polaroid backs and shift and tilt lenses in a variety of focal lengths, are available at very competitive prices. For shooting details quickly in a room for an editorial feature, where quantity as well as quality is of the essence, they are unbeatable.

17

useful equipment

the shift lens

When photographing a tall building or a room with a high ceiling, it might not be possible to get all the detail that you want in the frame. To achieve this, it might be necessary to point the camera upwards. The problem with doing this is that the vertical lines of the building or room will start to converge. In other words, lean inwards. Although in certain situations, this can have a dramatic effect that can be used as a creative tool, it rarely works for interior photography. This is where the shift lens, or as it is sometimes called the perspective control (PC) lens, is an invaluable asset to the photographer's kit.

When using one of these lenses to photograph a large room or hall, instead of tilting the camera up to fit in the whole of the interior, the camera can be kept perfectly level. Of course, this will cut out the detail at the top of the frame. However, by turning a small knob on the side of the lens, its axis can be shifted relative to the film plane: the lens is moved upward but kept parallel to the film. This is what is known as the 'shift'. The whole room now appears in the picture, but with a difference. All the verticals are completely parallel, even if the lens has been shifted as far as it can go.

The lenses are also invaluable when photographing an interior with a lot of reflective surfaces, such as mirrors. Imagine you are facing a wall with a large mirror hung at its centre. You want to photograph, with perfect symmetry, the whole wall but if you stand right in front of the mirror, both you and the camera together with the tripod, will be reflected in it, therefore ruining the shot. With a shift lens you can choose a viewpoint to one side of the mirror. Here you will not be reflected, but the mirror will no longer be centered and one side of the wall will be cut off. By using the shift facility on the lens to perform a horizontal movement, you will be able to bring the mirror back to the centre of the picture and have the whole wall in as well. The difference is that now you will not be reflected in the mirror.

lighting

If additional lighting is required, then by far the most popular choice is electronic flash. Not only can some of these units be extremely powerful but they are also balanced for daylight. This means that if you are combining daylight, coming in through a window for example, with electronic flash, you can use daylight balanced film without the need to gel either the windows or the flash. This makes them extremely quick to work with. There are many models available ranging from the mono-bloc – this has the power pack and controls built into the head but has rather limited power – to separate units that you plug the head into. Many of these can take more than one head and can work asymmetrically. That is to say that each head can work at a different output. This is an extremely useful asset. Some packs may have the facility to program multiple flash. This means that if, even at full power one flash is insufficient, a number of flashes can be fired automatically as soon as the unit has recharged.

There are a variety of different reflectors available for these units. These could range from what is known as a standard silver reflector to which you can add barn doors, honey combs, snoots or umbrellas, through to soft boxes of varying sizes. Many photographers prefer to bounce these lights off a white wall or ceiling, for example, to give an even distribution of illumination. Care must be taken when lighting like this, that the surface that the light is directed toward is completely neutral, otherwise there is the chance of causing a colour cast. As with cameras, it is only through experience that you will get to know what is the best lighting system for you and your style of photographing interiors.

gels and filters

Having composed and lit your shot, the next consideration is the balance of the light in relationship to the film being used. If the interior that you are photographing is lit by daylight, then daylight film is fine even when combining it with electronic flash. If the room is lit with tungsten light, then tungsten balanced film will be required. But what if the room is lit with fluorescent light or the available tungsten light is too low to shoot in? If you are shooting with only available fluorescent light, which might look white to the naked eye, it will in fact record with a green cast on film. To correct this, a correction filter needs to be fitted over the lens. These are magenta in colour and come in different values and will remove the green cast. The problem, though, is further complicated by the variety of different fluorescent tubes that might be being used. These range from cool daylight through to warm white. This is where a colour temperature meter comes into its own as it will indicate precisely what filter is required. If you need to add light to a room lit with fluorescent lights, you could use electronic flash and place a gel over the flash head. This would be green in colour, to balance it to the available light. With the magenta correction filter on the camera both sources will record as normal on the film. This technique can be used when similar problems occur with available tungsten light. Here, however, the gel placed over the flash would be orange in colour and providing tungsten balanced film was being used, then no filter would be required on the camera. Many interior photographers have a swatch that contains the full range of colour correction filters and is available from a company called, Rosco, who also manufacture the gels.

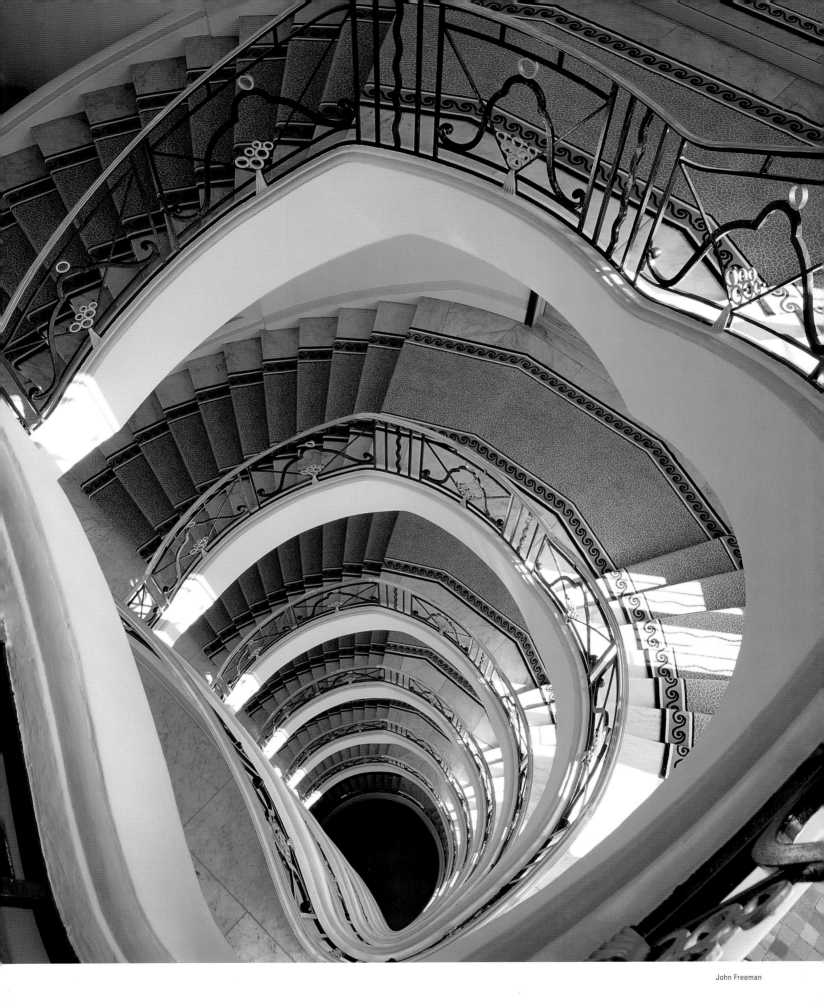

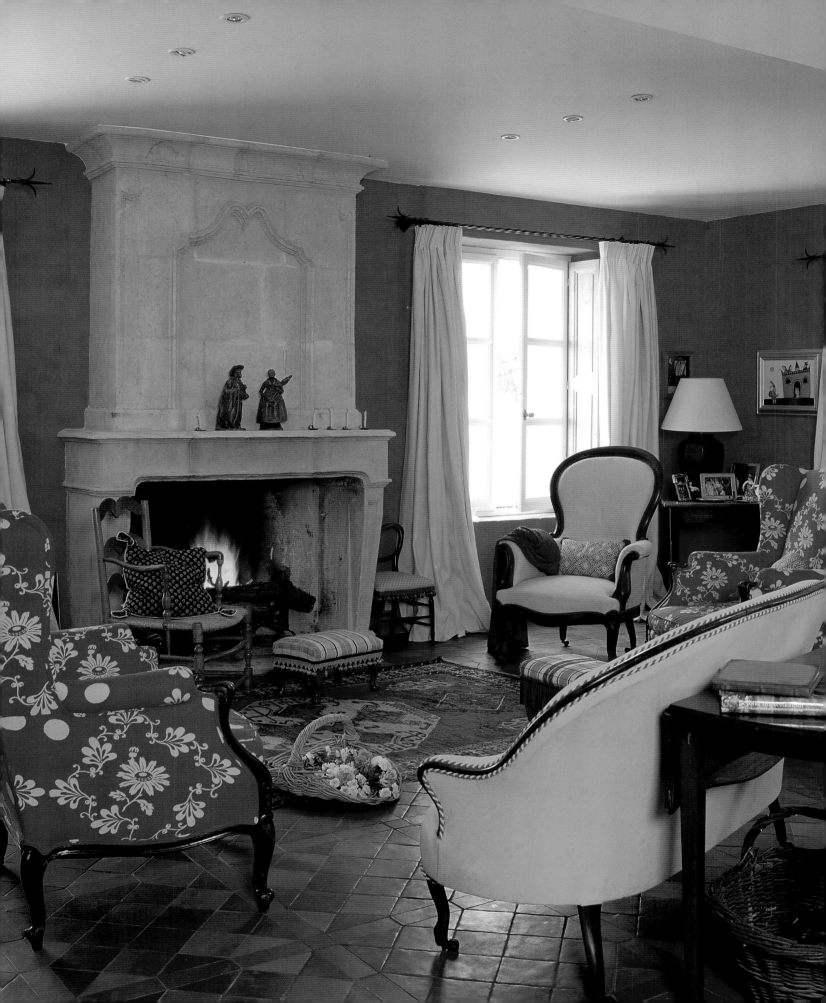

Preparing to style a room is a curious occupation. Firstly, the whole shoot takes place within another person's home. The commissioning magazine requires the house to have a certain look – period, contemporary, high-tech or minimalist – that fits in with the magazine's look of the month. The magazine commissions the work at least 3 months before publication, so it is important to select the right props for the appropriate season: flowers, clothing, etc.

On visiting the property I always try to warn the homeowner that I will be bringing props. These can be very diverse. The magazine may wish to use different dining room chairs, so I have to mention this tactfully. I always arrive with seasonal fruits, flowers, fabric throws and additional cushions. The most delicate task for a stylist is to reflect the homeowner's room while giving the magazine the shoot it requires. As you can imagine, while it is easy to explain moving a chair to hide a plug, it is more difficult to remove a picture or change the position of furniture within the room to make it more suitable for the shoot. Having created the look that I require, the photographer then has to work around the lighting issues presented by windows for instance. A stylist should always consider the problems lighting can cause photographers.

My prop-box holds a store of gadgets ranging from sellotape, blutack and drawing pins to picture nails, a small hammer and pliers. While the main shot is time consuming, particularly if it is for a cover, the detail shots are usually easy and fun, reflecting the combined resources of the owner, photographer and stylist.

21

All pictures John Freeman

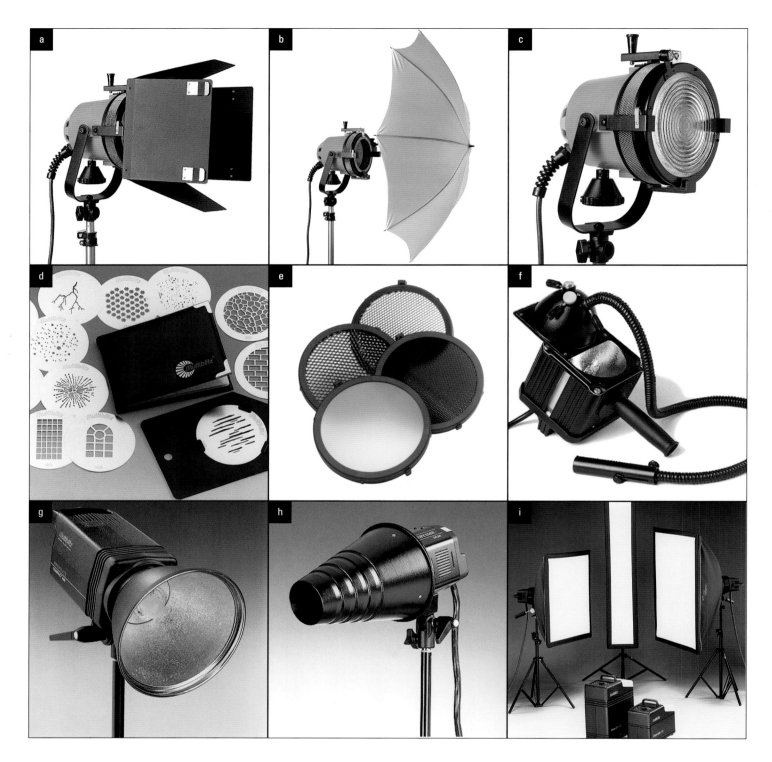

glossary of lighting terms

Acetate
Clear plastic-like sheet often colour-tinted and fitted over lights for a colour cast

Ambient light
Naturally occurring light

Available light
See Ambient light

Back-projection
System in which a transparency is projected onto a translucent screen to create a backdrop

Barn doors (a)
Set of four flaps that fit over the front of a light and can be adjusted to control the spill of the light

Boom
Long arm fitted with a counterweight which allows heads to be positioned above the subject

Brolly (b)
See Umbrella

CC filters
Colour correction filters, used for correcting any imbalance between films and light sources

Continuous lighting
Sources that are always on, in contrast to flash, which only fires briefly

Cross-processing
The use of unconventional processing techniques, such as developing colour film using black & white chemistry

Diffuser
Any kind of accessory which softens the output from a light

Effects light
Light used to illuminate a particular part of the subject

Fill light
Light or reflector designed to reduce shadows

Fish fryer
Extremely large softbox

Flash head
Studio lighting unit which emits a brief and powerful burst of daylight-balanced light

Flag
Sheet of black card used to prevent light falling on parts of the scene or entering the lens and causing flare

Fluorescent light
Continuous light source which often produces a green cast with daylight-balanced film – though neutral tubes are also available

Fresnel (c)
Lens fitted to the front of tungsten lighting units which allows them to be focused

Giraffe
Alternative name for a boom

Gobo (d)
Sheet of metal or card with areas cut out, designed to cast shadows when fitted over a light

HMI
Continuous light source running cooler than tungsten but balanced to daylight and suitable for use with digital cameras

Honeycomb (e)
Grid that fits over a lighting head producing illumination that is harsher and more directional

Incident reading
Exposure reading of the light falling onto the subject

Joule
Measure of the output of flash units, equivalent to 1 watt-second

Kelvin
Scale used for measuring the colour of light. Daylight and electronic flash is balanced to 5500K

glossary of lighting terms

Key light
The main light source

Kill spill
Large flat board designed to prevent light spillage

Lightbrush (f)
Sophisticated flash lighting unit fitted with a fibre-optic tube that allows the photographer to paint with light

Light tent
Special lighting set-up designed to avoid reflections on shiny subjects

Mirror
Cheap but invaluable accessory that allows light to be reflected accurately to create specific highlights

Mixed lighting
Combination of different coloured light sources, such as flash, tungsten or fluorescent

Modelling light
Tungsten lamp on a flash head which gives an indication of where the illumination will fall

Monobloc
Self-contained flash head that plugs directly into the mains (unlike flash units, which run from a power pack)

Multiple flash
Firing a flash head several times to give the amount of light required

Perspex
Acrylic sheeting used to soften light and as a background

Ratio
Difference in the amount of light produced by different sources in a set-up

Reflector
1) Metal shade around a light source to control and direct it **(g)**
2) White or silvered surface used to bounce light around

Ringflash
Circular flash tube which fits around the lens and produces a characteristic shadowless lighting

Scrim
Any kind of material placed in front of a light to reduce its intensity

Slave
Light-sensitive cell which synchronizes the firing of two or more flash units

Snoot (h)
Black cone which tapers to concentrate the light into a circular beam

Softbox (i)
Popular lighting accessory producing extremely soft light. Various sizes and shapes are available – the larger they are, the more diffuse the light

Spill
Light not falling on the subject

Spot
A directional light source

Spot meter
Meter capable of reading from a small area of the subject – typically 1–3 degrees

Stand
Support for lighting equipment (and also cameras)

Swimming pool
Large softbox giving extremely soft lighting (see also Fish fryer)

Trace
See Scrim

Tungsten
Continuous light source

Umbrella (b)
Inexpensive, versatile and portable lighting accessory. Available in white (soft), silver (harsher light), gold (for warming) and blue (for tungsten sources). The larger the umbrella, the softer the light

24

practicalities

How to gain the most from this book

The best tools are those which can be used in many different ways, which is why we've designed this book to be as versatile as possible. Thanks to its modular format, you can interact with it in whichever way suits your needs at any particular time. The material is organized into self-contained double-page spreads that look at the work of a particular photographer in depth. In each case, there is a diagram, which shows the lighting setup used, based on information supplied by the photographer. Naturally, the diagrams should only be taken as a guide, as it is impossible to accurately represent the enormous variety of heads, dishes, softboxes, reflectors and so on that are available while using an accessible range of diagrams, nor is it possible to fully indicate lighting ratios and other such specifics. The scale, too, has sometimes had to be expanded or compressed to fit within the space available. In practice, however, differences in equipment and sometimes scale, should be small and will anyhow allow you to add your own personal stamp to the arrangement you're seeking to replicate. In addition you'll find technical details about the use of camera, film, exposure, lens etc. along with useful hints and tips.

understanding the lighting diagrams

three-dimensional diagrams

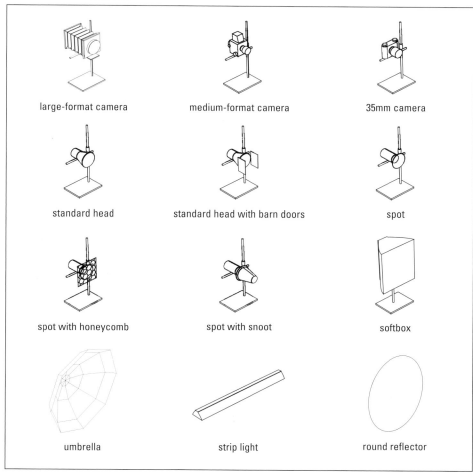

large-format camera medium-format camera 35mm camera

standard head standard head with barn doors spot

spot with honeycomb spot with snoot softbox

umbrella strip light round reflector

25

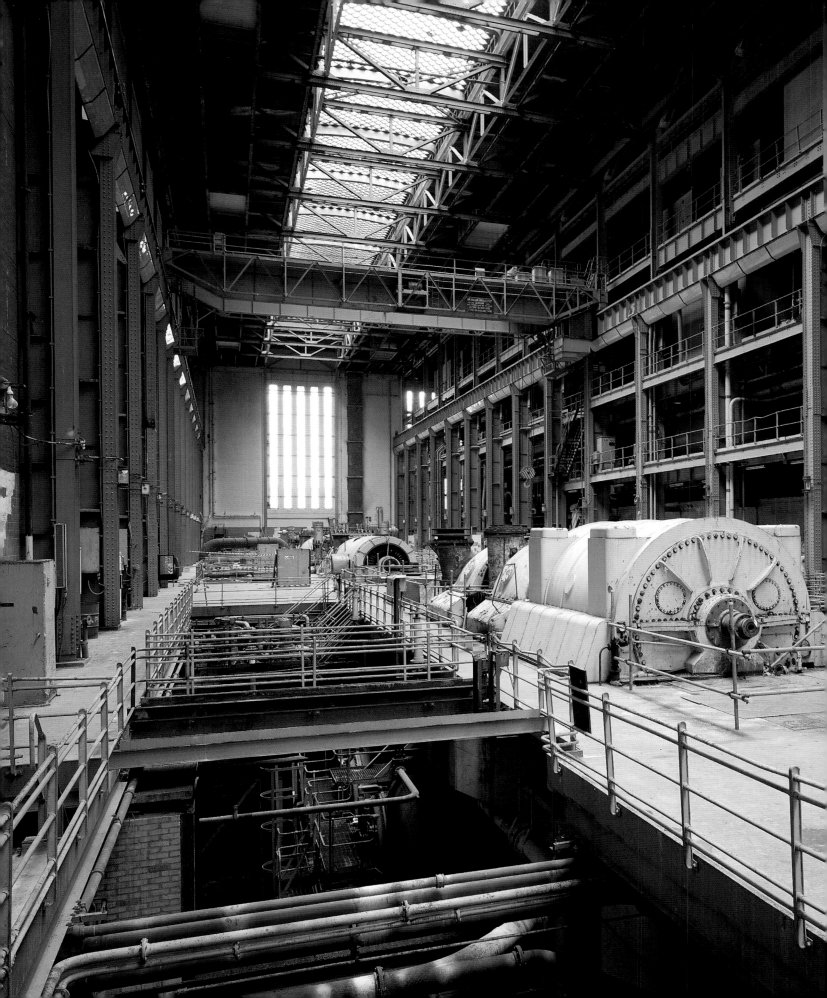

daylight

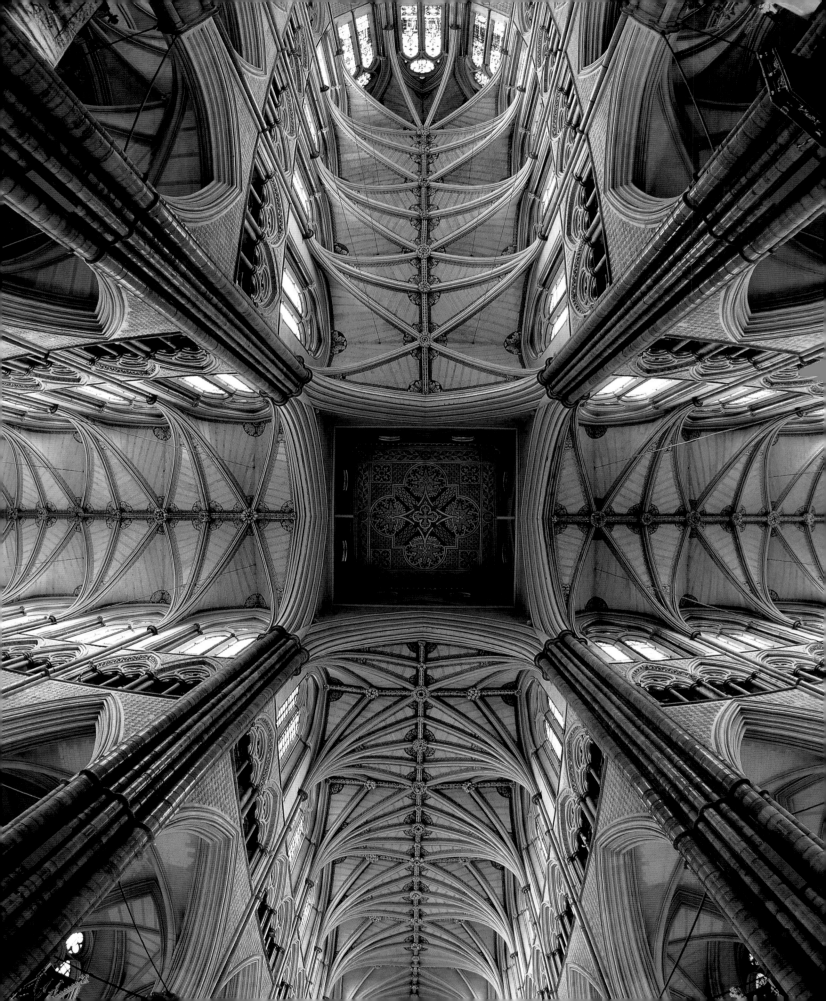

Fish-eye lens shots can often look gimmicky and ugly, but used thoughtfully they can produce extremely stylish results. Arriving very early in the morning, before the crowds of tourists built up, at Westminster Abbey in London, I chose this viewpoint looking up at the ceiling. At first I chose a 50mm wide angle lens for my Mamiya RZ67, but even with the camera as low as I could get it on the tripod the angle of view was too limited. I changed this lens for a fish-eye and immediately knew it was the right choice. Using a spirit level, I made sure that the lens was square in all directions and that the camera was perfectly centred. Fortunately it was an overcast but bright morning. This softened the light coming in through the windows and created an even spread. I had to lie on the floor on my back so as not to appear in the shot while I was taking it and checked on a Polaroid that there wasn't any flare or unevenness with the light.

John Freeman
Editorial
Book
Mamiya RB67
Fish-eye
Kodak Ektachrome 64
1 sec @ f/8
Daylight

westminster abbey london, uk

This striking kaleidoscopic view of an iconic structure proves that, by seeking out unusual viewpoints, even the most familiar buildings can be photographed in new and refreshing ways.

This interior was lit entirely with daylight. It is a perfect example of a classically beautiful daylight shot that portrays the cool, almost monochromatic ambience of this modern hotel. Its effectiveness is its simplicity, but this belies the problems that can occur when using daylight. To begin with, if it is a bright but cloudy day, the sun disappearing and then reappearing from behind a cloud can play havoc with the exposure. Having selected the viewpoint and decided that the shafts of light coming through a window look attractive, it's galling to see them disappear just as you are about to fire the shutter because of a cloud passing in front of the sun. Even moreso when you wait patiently, only to discover when the sun reappears that the light patterns are in a totally different position and they do not look anything like they looked before. Another problem can occur if the sun is shining very brightly and coming straight through the windows. The sunlight creates pools of light that are so harsh they get burnt out in the final exposure. If this is the case then either tracing paper (or some other diffusing material) must be placed over the windows, or flash may be required to balance the illumination.

Andreas Von Einsiedel
Editorial
Magazine
Hasselblad
40mm
Kodak EPP
1/4 sec @ f/16
Daylight

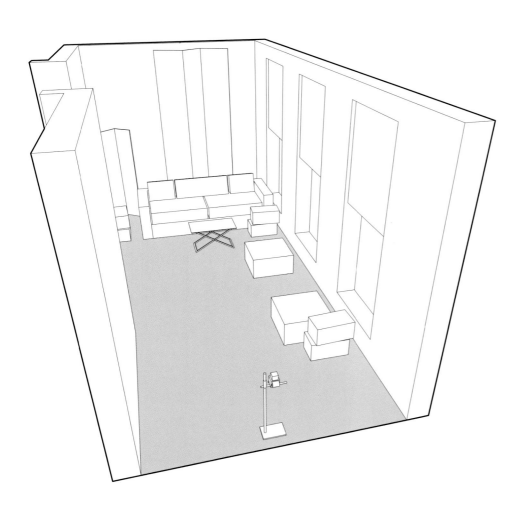

the hempel hotel london, uk

Apparently simple daylight lit shots can often be more complicated to make than they at first appear.

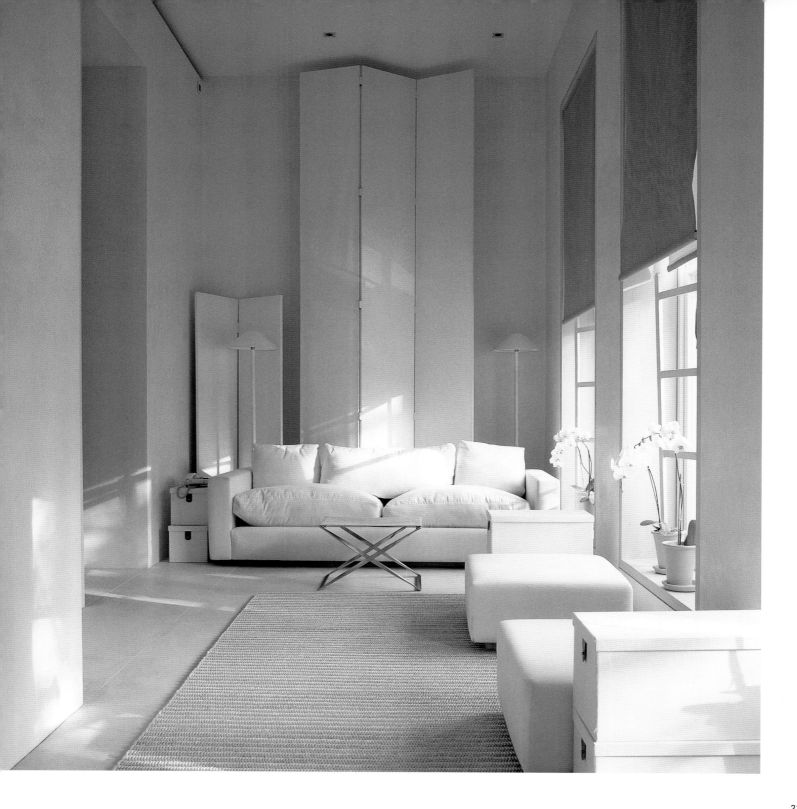

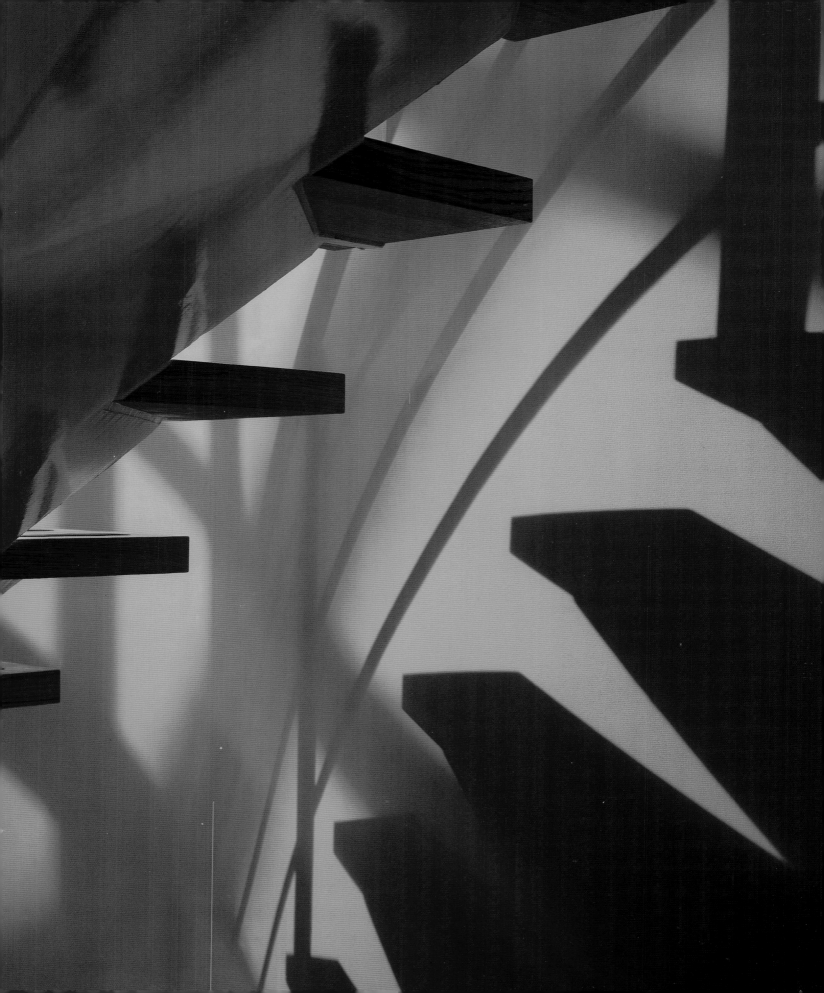

This shot typifies the "chance factor" – a stroke of luck scenario that's almost impossible to plan for but necessary to react to. And quickly. I was working in and around a large industrial facility which had a dramatic staircase in the foyer. The wall behind the staircase was curved and painted scarlet. I'd drifted through the space several times during the morning and had planned to do a shot within the space at some point during the shoot. In front of the stairs was a narrow window, which was floor to ceiling in height. As chance would have it, I was walking through the reception area when I realised that the sun was hitting the gap between the stair treads and the curved wall, casting tremendous shadows along its length. I could see that within five minutes the scene would be lost as the thin slither of sun would have moved on. I grabbed the camera, shot a Polaroid and went for the film. A white, glazed tile floor ensured that enough light was bouncing back upwards, which was a relief because otherwise I'd have needed to softly light the shadow areas, and there simply wasn't enough time!

Martine Hamilton Knight
Corporate
Brochure
Linhof Technikardan 45
210mm
Fuji Provia 100
1/4 sec @ f/22
Daylight

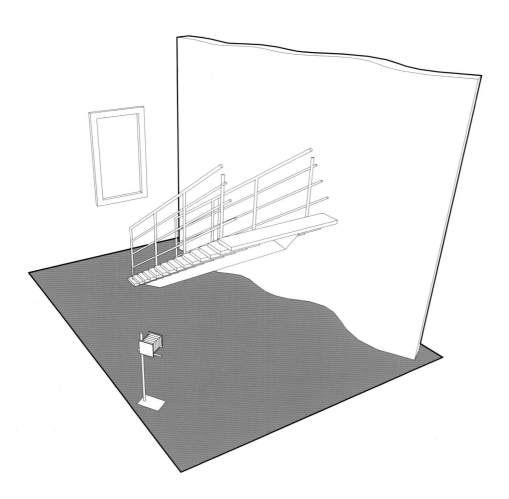

red staircase london, uk

Always be on the lookout for interesting details which capture the spirit of a place.

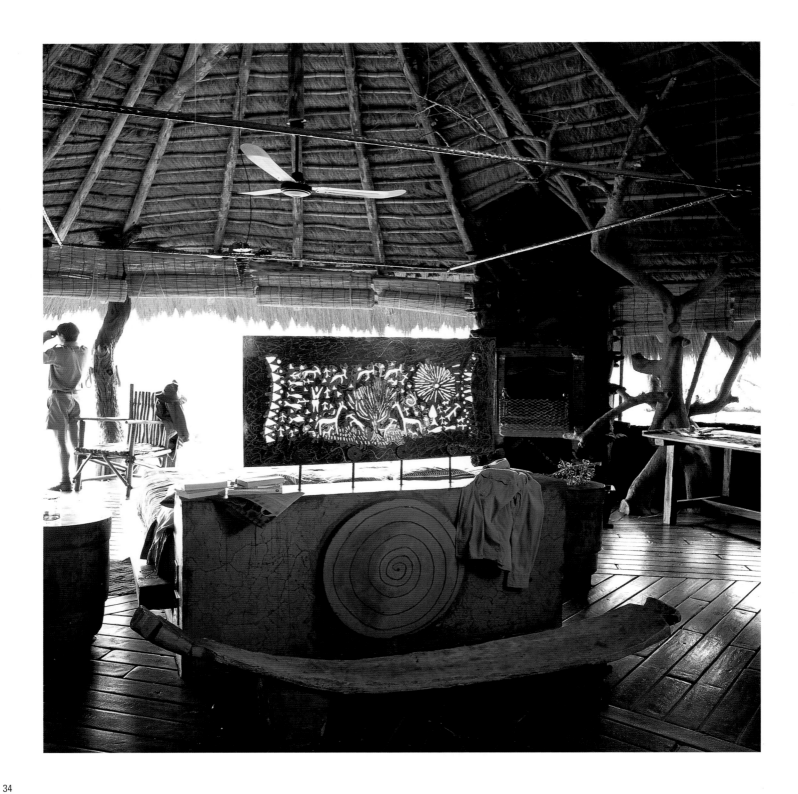

Travelling through the African bush is fraught with many problems for the photographer. The biggest one of all is probably the lack of electricity in most locations, making you totally dependant upon daylight, oil or candlelight, and the use of portable reflectors. I tend to use a variety of different ones but here, I chose a large, 6' x 4' collapsible reflector, white on one side and gold on the other.

I took this shot towards the back of the bed – can you imagine sleeping here and waking up to that view! I had to let the outside of the room blast out because it was the detail inside that I wanted to emphasize. There was enough light to expose the roof, but the bed-head and the stool in front of it needed a little help from the reflector to balance the light more evenly. I like to think that if I had lit the room with flash so that it balanced with the outside, the atmosphere of the surroundings would have been lost and the final shot would not have been as evocative as this one.

Jan Baldwin
Editorial
Book
Hasselblad
40mm
Fuji Provia II 100
1/2sec @ f/16
Daylight

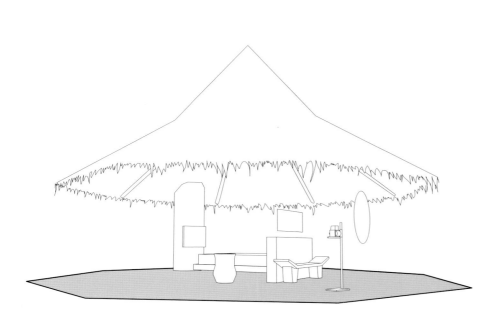

private house northern transvaal, africa

With scenes such as this, where the contrast range is too great for the film to record, the photographer must decide which elements are the most important and bias the exposure accordingly.

Daylight was not a problem when it came to photographing this fantastic house in Johannesburg, South Africa. The curved ceiling, which spanned the entire length of the room, was made of the most amazing squares of frosted glass. Whether it was bright or overcast, these diffused the daylight, creating the most even spread of lighting that you could wish for. Together with the upper windows that ran along the full length of both walls, there was no need for any additional lighting.

I chose this viewpoint from the bed so that it gave prominence to the ceiling without the need to look up. Although the 50mm lens slightly exaggerates the length of the room, I selected it because I wanted to include as much of the roof as possible. The overall effect is that of an unusual living space that is bathed in daylight.

Jan Baldwin
Editorial
Book
Hasselblad
50mm
Fuji Provia 100
1/4 sec @ f/16
Daylight

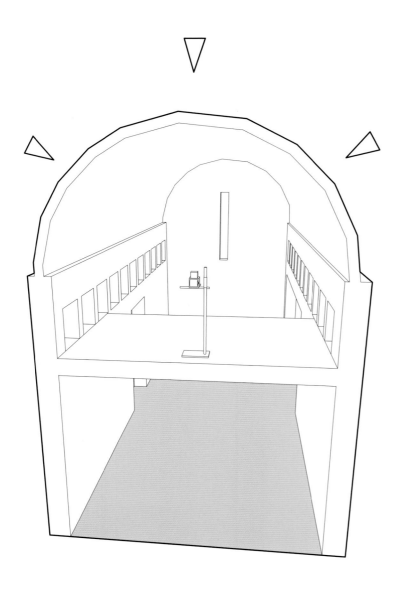

private house johannesburg, south africa

Emphasising an unusual feature in a room can make for an exceptional photograph.

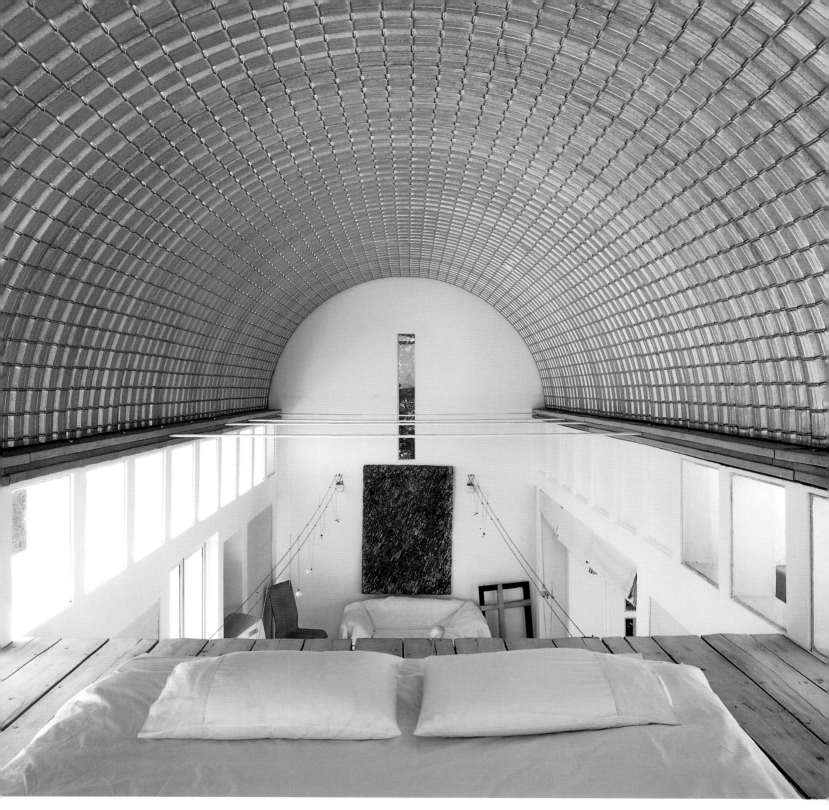

Fortunately this railway carriage at Hejaz railway station, Damascus, Syria, was positioned at just the right angle for the light entering it. Even the somewhat dirty windows add to the atmosphere of the interior with its faded empire flavour.

The dark table in the centre needed something to "lift" it, so I placed a white cloth, vase and bowl with a white napkin on it to add an extra something. The newspaper on the right also helps what otherwise would have been a pretty grubby piece of cloth. To the left of the camera viewpoint I placed a small reflector to bounce in some extra light.

- (人) Tim Beddow
- (✎) Editorial
- (◈) Magazine
- (▣) Mamiya RB 67
- (◉) 65mm
- (▤) Kodak EPP 120
- (◷) 1/2 sec @ f/11
- (◉) Daylight

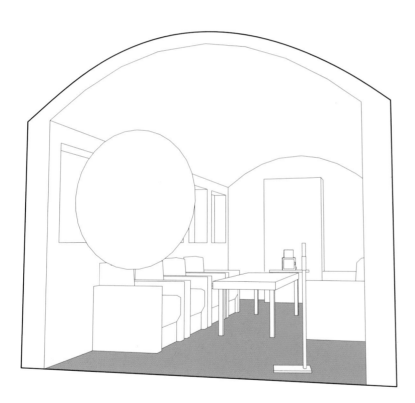

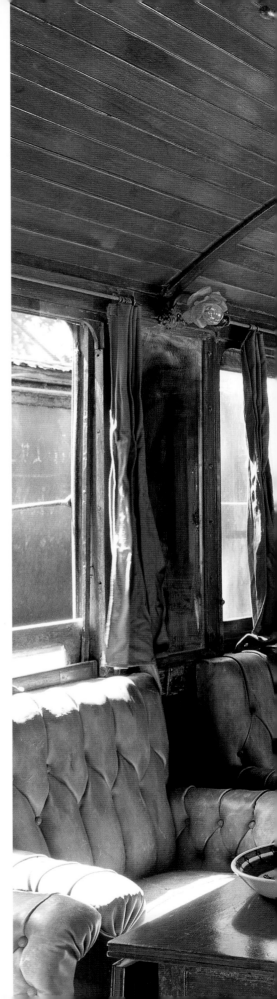

38 # damascus syria

Props such as table cloths and newspapers can act as useful reflectors or brighten up a dull corner of a scene.

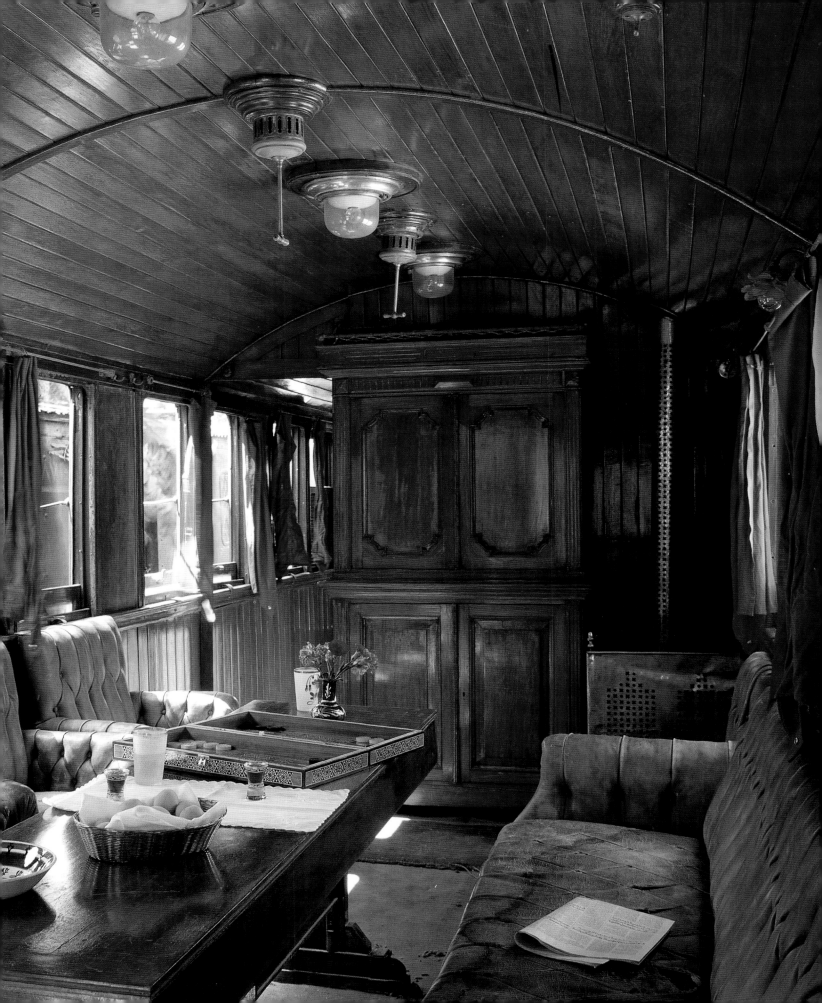

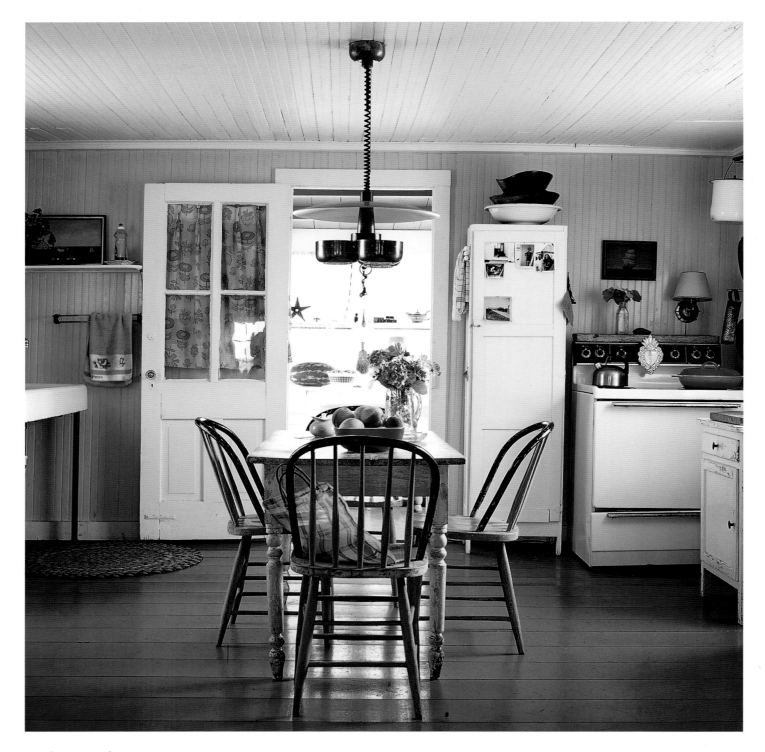

40 **private house** long island, usa

The ambience here is one of tranquility, most of which is created by the quality of the daylight and the simple furnishings of the kitchen.

I was photographing this house for a book on Waterside living, which I had been commissioned to illustrate. We had been on the east coast of America for two weeks and this was the first sunny day that we had had without rain. The room was lit entirely with daylight. Fortunately, it was late in the morning and the sun was quite high. This meant that there were no strong shafts of light coming in through any of the windows or doors. The two walls to the right and left and the wall behind me all had windows in them, which helped to create an even light. I chose to face the door, which I opened so that neither the camera nor myself would be reflected into it. This would have been a bigger problem had I been facing one of the windows. I deliberately overexposed the view beyond the door as I did not want this to detract from the general composition. The overall ambience is one of tranquility, most of which is created by the quality of the daylight and the simple furnishings of the kitchen.

- Jan Baldwin
- Editorial
- Book
- Hasselblad
- 180mm
- Fuji Provia 100
- 1/2 sec @ f/11
- Daylight

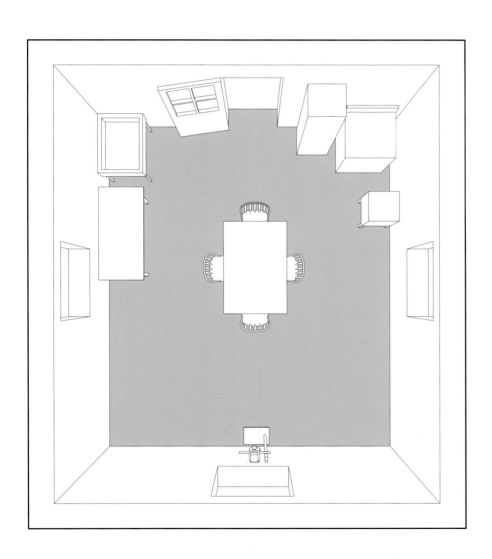

This is a good example of how daylight can make a shot work for you. The room was minimalist in its decoration. The left-hand wall was completely covered by a venetian blind. The window that it concealed appeared as a rectangular block of light. I set the camera up and chose my viewpoint. I fitted a 50mm lens to the Hasselblad and made sure that the camera was completely level so that I would not have any converging verticals. By carefully adjusting the slats of the blind I could control not only the angle of the light but also its intensity. Moreover, I did not want to lose the dappled light that was filtering through the trees. Once I had got it to fall on the wall and spill onto the bench and floor in the way that I wanted, I took my exposure reading. The result is a shot that has a painterly appearance.

- ⊛ Richard Davies
- ⊘ Editorial
- ◉ Magazine
- ⊜ Hasselblad
- ⊛ 50mm
- ⊡ Kodak EPP 120
- ⊙ 1/2 sec @ f/22
- ⊙ Daylight

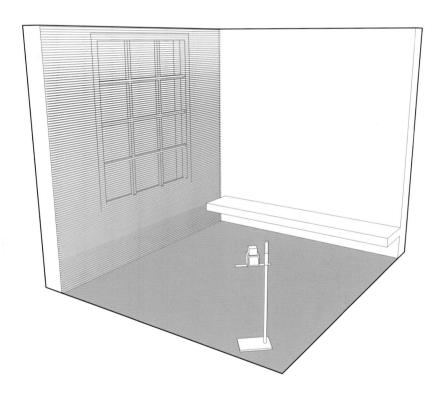

42

minimalist apartment london, uk

Less is sometimes more.

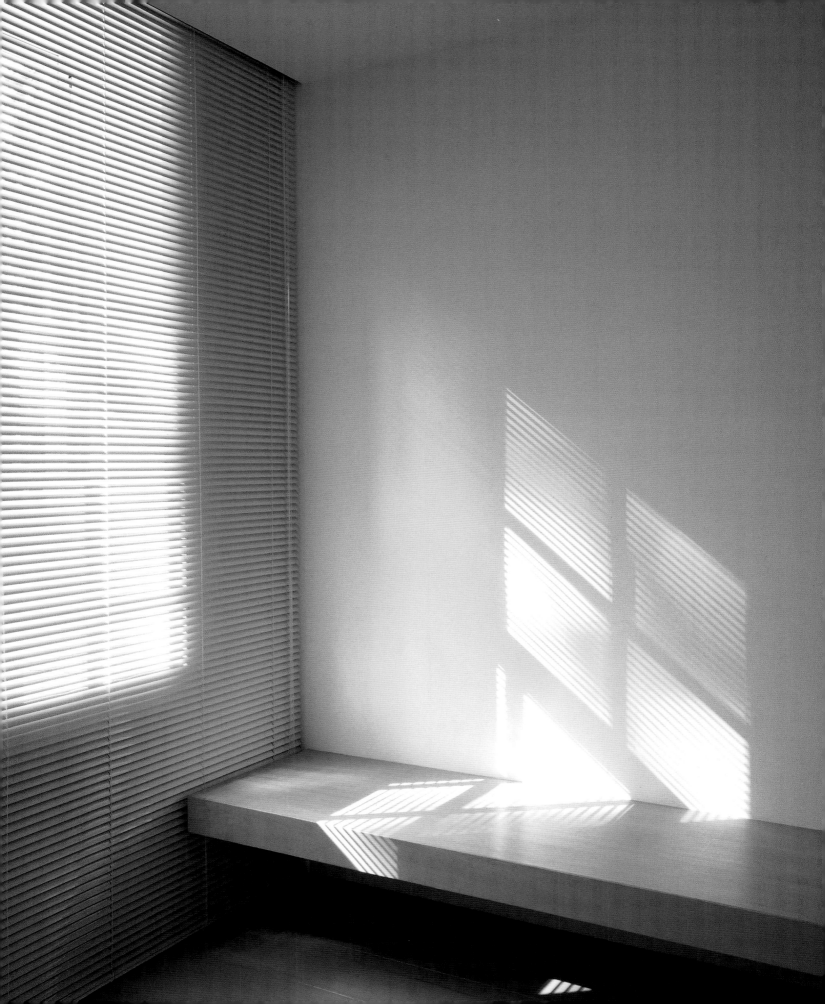

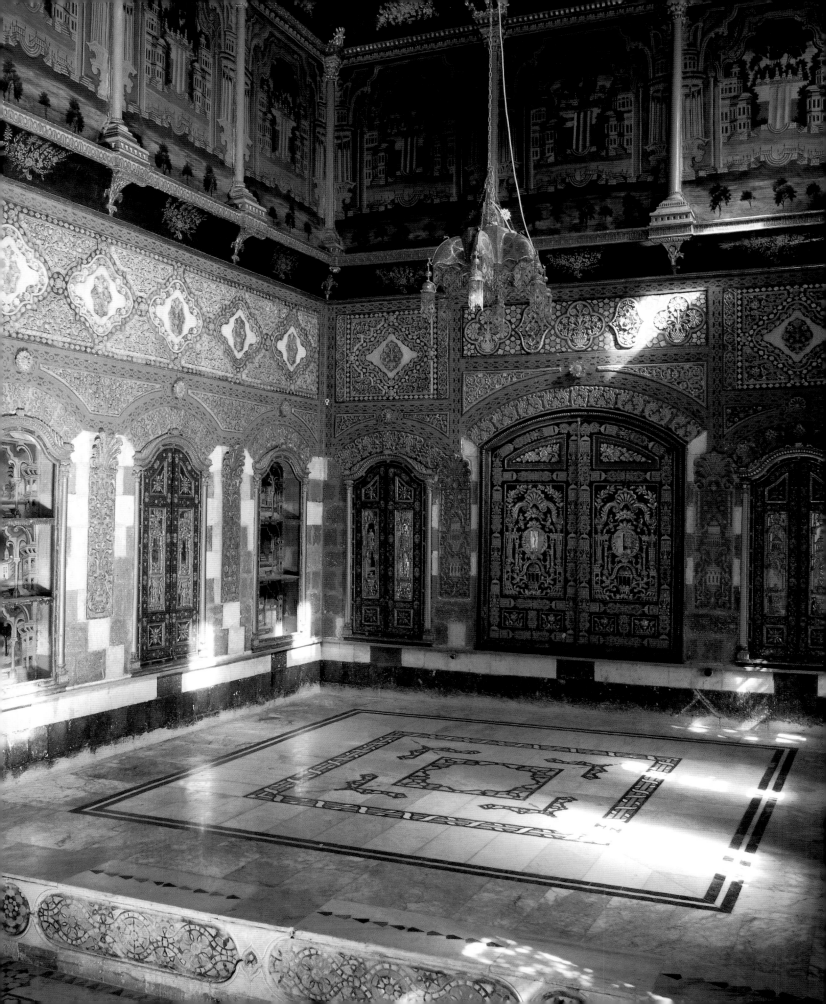

This picture of the qu'a of the main reception room of Beit Nizam, Damascus, Syria, was shot entirely in daylight. Timing, as with so many pictures where daylight is the main or only light source, was critical. A courtyard house like this has windows only to one side and the rooms can therefore seem very gloomy when viewed in the wrong light.

This angle was chosen because the windows would have burnt out completely if the camera had been pointing towards them. Because the 65mm lens did not have a shift facility, the camera was placed as high as possible on the tripod and kept completely horizontal. Early morning light was no advantage in this situation, as the sun simply could not get into the building intensely enough. The light-coloured marble floor acts as a natural reflector and coupled with the decorative stone, the mirrors placed behind the wooden fretwork and the intricate plasterwork, gave a charming dappled lighting effect.

ⓐ Tim Beddow
ⓑ Editorial
ⓒ Book
ⓓ Mamiya RB67
ⓔ 65mm
ⓕ Kodak EPP 120
ⓖ 1/2 sec @ f/11
ⓗ Daylight

beit nizam damascus, syria

Intricate patterns and shapes within the architecture can help to create pleasing lighting effects.

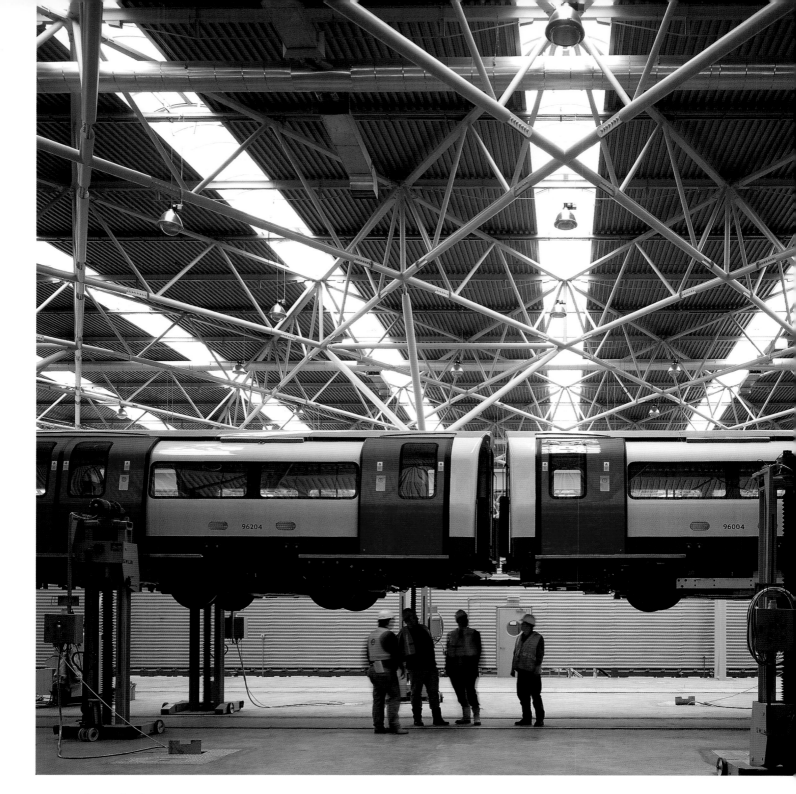

stratford depot london, uk

In this field of photography you must always be prepared to work quickly and without much warning.

ⓧ Dennis Gilbert
ⓧ Architect: Chris Wilkinson Architects
ⓧ Editorial for magazine and book
ⓧ Linhof Technikardan 4x5
ⓧ 90mm, with 15 magenta and 81A filters
ⓧ Fuji Provia 100
ⓧ Daylight
ⓧ 1 sec @ f/16

This train garage for the new Jubilee Line underground stations was completed some years before the new line, and I was photographing it without any trains for several days, and dodging the construction workers who were finishing off parts of the building. Then I was told that there would be a dummy inspection set up, and without much warning, I had to get ready as some underground bosses were going to be there as well, and for a limited time. I took a straightforward approach and stood well back. The result is amusing, but perhaps because of the position of the train (obscuring a sizeable section of the shed), I would guess that the architects would not put the picture in their top three of the building. The available daylight, which came through plastic roof-lights, needed some correction.

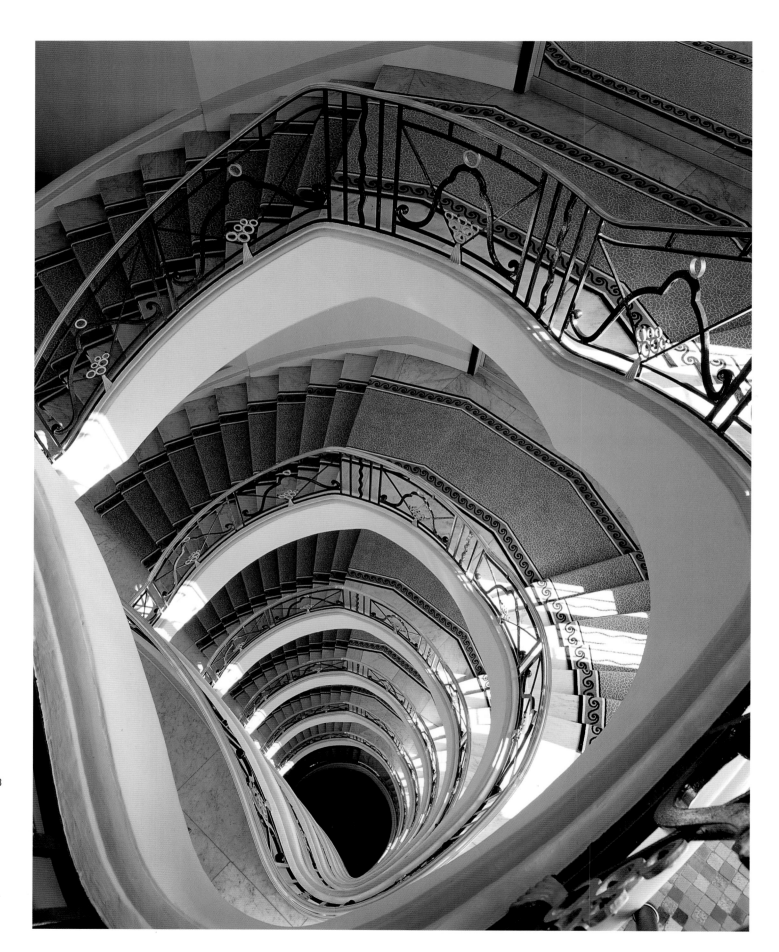

I was photographing the Hôtel Martinez, with its famous Palme d'or Restaurant, in Cannes on the Côte d'Azur. One day I decided to have a wander around the hotel in search of something different to photograph. Towards the rear of the building I came across this staircase. Although you could see the balustrades from the lifts, it wasn't until you looked down the stairwell that the full impact of the view revealed itself. I worked out that it would be best photographed in daylight and that the best time to do this would be at eleven o'clock in the morning. Returning the next day I set up the Mamyia on the tripod and examined several angles with an assortment of lenses. I decided to use a 50mm as this took in the whole staircase and gave good depth of field. At eleven o'clock the sun had moved round and shone in through the windows on the right, which were replicated on each of the floors below. Although I changed position several times it was this angle that I felt worked best.

ⓧ John Freeman
ⓧ Editorial
ⓧ Magazine
ⓧ Mamiya RZ67
ⓧ 50mm
ⓧ Kodak 100VS
ⓧ 1 sec @ f/11
ⓧ Daylight

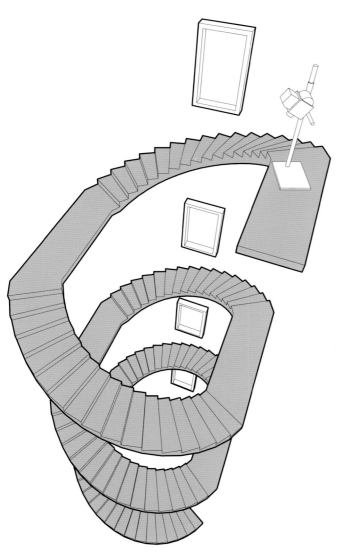

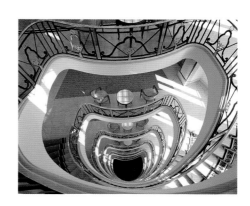

hôtel martinez cannes, france

Biding your time for the right moment will usually pay dividends in the long run.

This was how the Tate Modern in London looked just before it was converted from a power station into England's finest gallery of modern art. What you see here is the old turbine hall that has now been completely gutted. There was no way that I could light such a vast area and so I went with the daylight that was coming in through the skylights and the large windows at either end. It was quite an overcast day and the light levels were very low. Although I was shooting in daylight, I decided to use Kodak EPY (a tungsten-balanced emulsion) and place an 85B filter over the lens to balance the film to daylight. I chose this approach because I knew it was going to be a very long exposure and I was concerned that if I used daylight film, I could face problems with reciprocity failure. As it turned out, the exposure was 2 minutes in length. What is amazing, is that even the lower ground floor areas have recorded sufficient detail and that the details of the windows have not burnt out.

- 🕴 Richard Davies
- 🖥 Advertising
- 🎯 Poster
- 📷 Sinar P 5x4
- 🔘 90mm
- ▶ Kodak EPY
- ⏱ 2 minutes @ f/22
- 💡 Daylight

50 **tate modern** london, uk

Tungsten-balanced film is better suited to long exposures as it suffers from reciprocity law failure less.

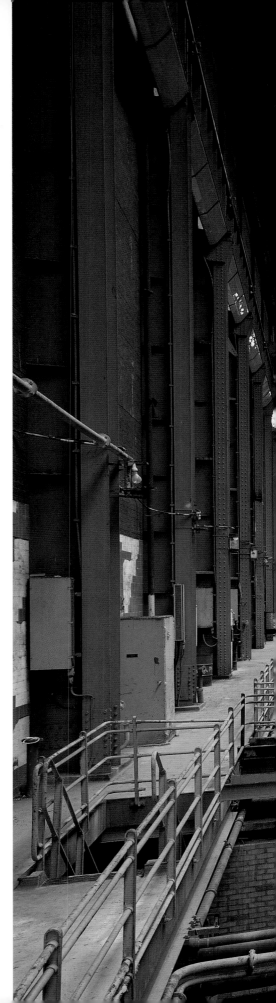

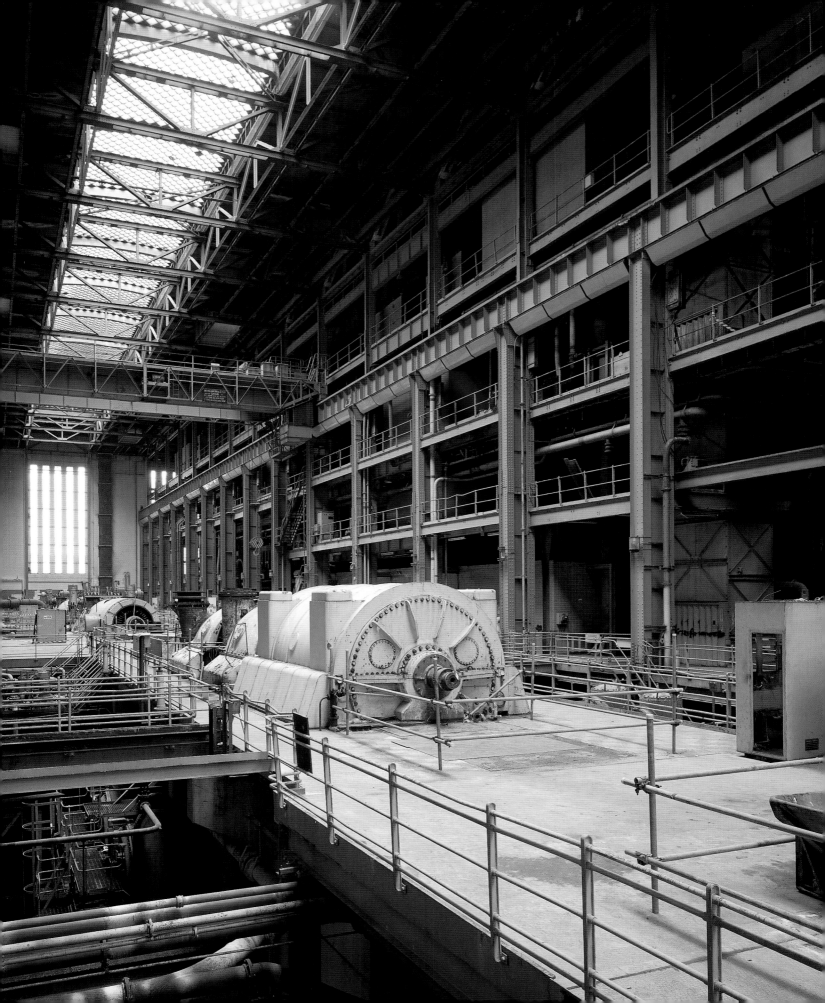

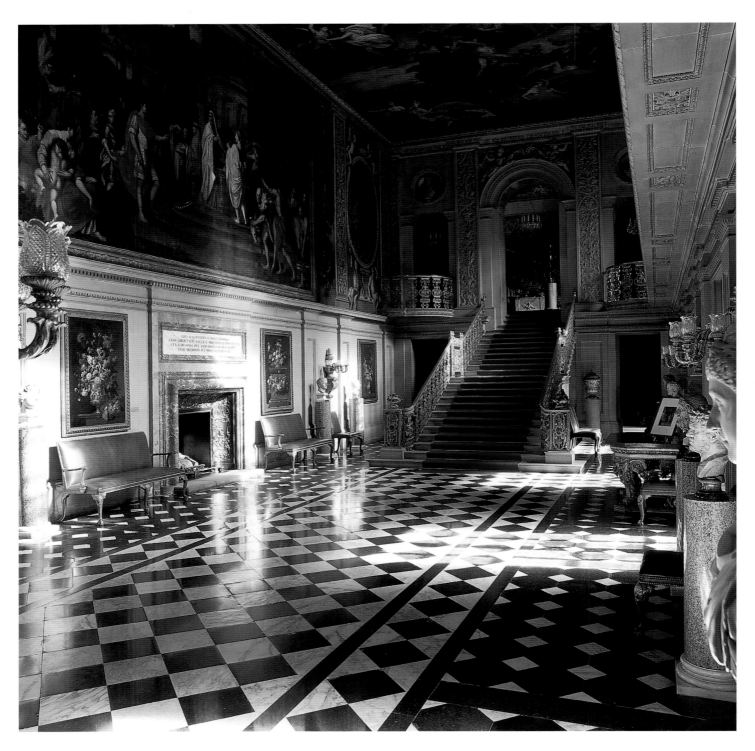

52 **painted hall** chatsworth, uk

Sometimes atmosphere is more important than detail.

This room has been photographed many times, from all angles and using various techniques. I therefore decided to go for atmosphere and sacrifice some of the information – specifically the detail in the lightest and darkest areas – to attempt a different shot. The most important decision was when to shoot, and then it was just a matter of waiting for the correct light.

It was springtime and, as the windows were west-facing, I opted for low sun in the evening at about 5.30 pm. All the house lights were switched off and I placed a series of reflectors to soften and distribute the light. This lifted the illumination in the darker areas and neutralised the light elsewhere. This was all done ahead of time. I then waited for the best light and thankfully it came as soft, slightly diffused late afternoon sun. Soft enough to bounce around the room. The shot worked because it was conceived and planned ahead of time. It may not show all the detail of the room but it does give a feel of the room bathed in atmosphere.

⊛ Simon Upton
⊙ Editorial
◉ Book
⊛ Hasselblad
⊛ 60 mm
⊛ Fuji RDP II
⊙ 30 secs @ f/22
⊙ Daylight

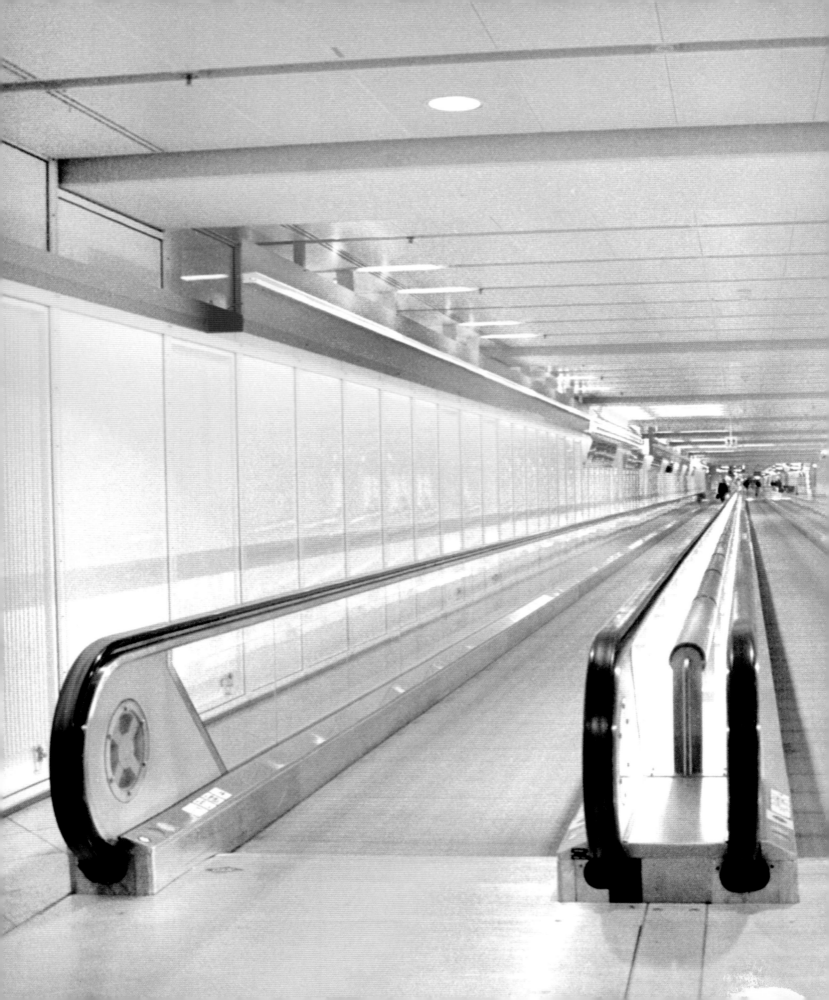

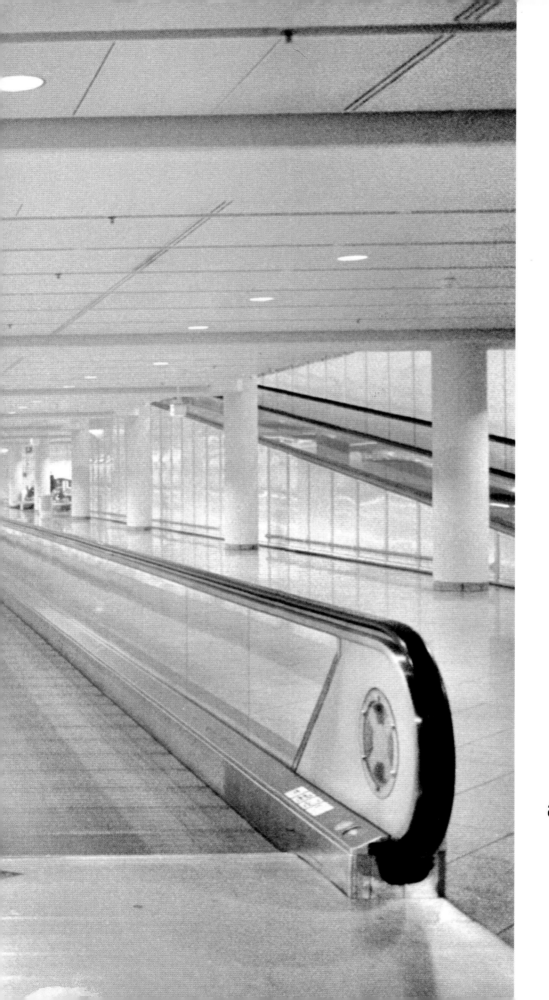

artificial light

This beautifully detailed stair is backlit by a wall of fluorescent lamps with yellow sleeves over them. I wanted the picture to give the wall of light and the structure equal weight, so that the content as well as the form would be a sort of reversible puzzle. Several times I have seen viewers unsure which way up the picture is supposed to go – which generally pleases me, though I am wary of pushing abstraction too far. This is an unusual lighting situation: obviously I didn't want to filter out all the yellow as the staircase is supposed to be that colour. But I needed to filter out the green cast that would be caused by the fluorescent light source, so I acted as if the yellow tubes were not there, and put 35M filtration on the camera.

Ⓐ Dennis Gilbert
Ⓑ Architect: Walters And Cohen
Ⓒ Editorial, for magazine
Ⓓ Linhof Technikardan 4x5
Ⓔ 120mm, with 35cc magenta filter
Ⓕ Fuji Provia 100
Ⓖ 6 secs @ f/22
Ⓗ Fluorescent tubes with coloured sleeves

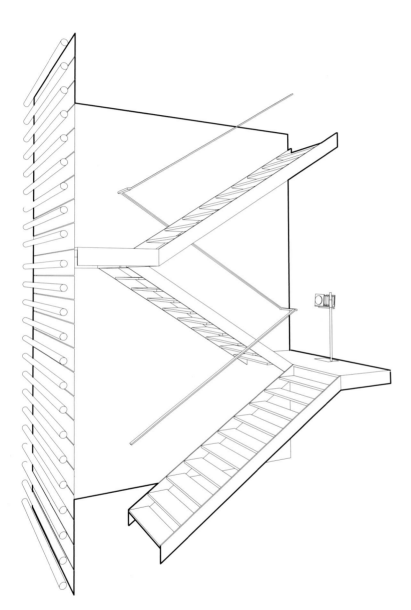

health club staircase london, uk

The combination of an abstract composition and bold colour has created a striking image.

This shot illustrates the problems of working with different light sources, in a situation where there isn't the time to gel lights or change bulbs to achieve an even colour temperature. The main body of the food hall was lit with tungsten bulbs, so I chose Kodak EPY tungsten balanced film. However, the ceiling above the food hall, which was decorated with superb ceramic tiles, was lit with fluorescent tubes all around its perimeter. The time I was given to capture this shot was fifteen minutes. This was the time between the displays being finished and the store opening to customers.

Having selected my viewpoint and chosen the lens, I made the decision to go with the tungsten light, even though I knew the ceiling would have a green cast. My thinking here was that the ceiling was very blue/green anyway and because it was heavily patterned, this cast would absorb itself into the decoration. If I had chosen to filter the fluorescent light, the rest of the hall would have turned magenta, which would have been totally unacceptable.

John Freeman
Editorial
Book
Sinar P 5x4
90mm
Kodak EPY
1 sec @ f/11
Ambient light

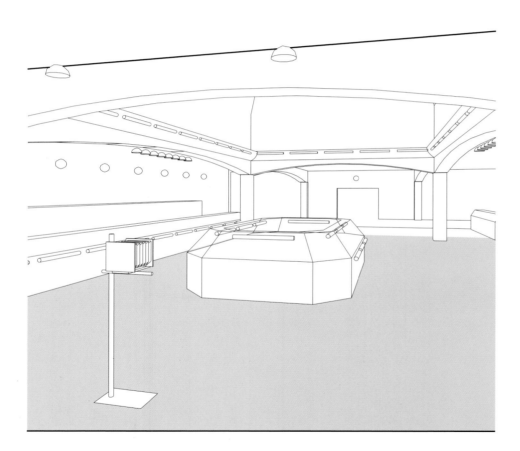

58 **harrods food hall** london, uk

Colour correction can be subjective. Sometimes a cast can add to the appeal of an image. Sometimes more than one cast is present, and a decision must be made as to which one to remove and which to leave alone.

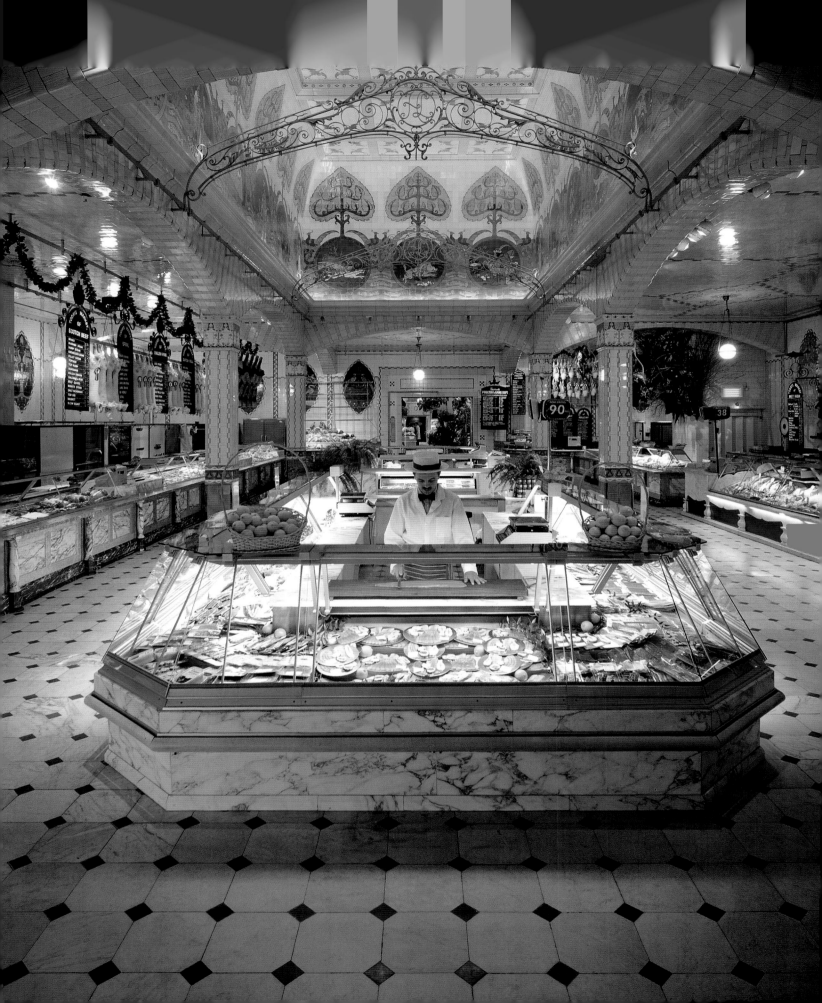

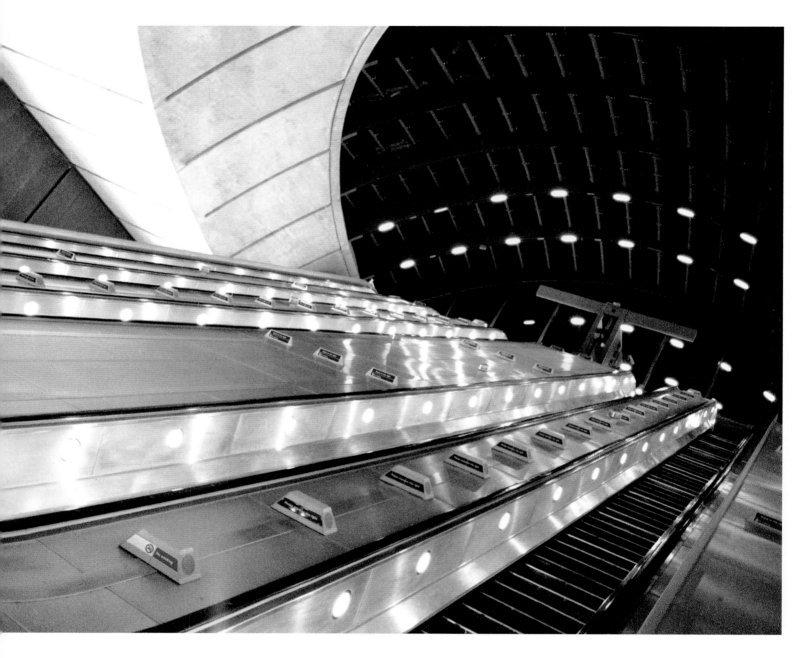

Places like underground stations are hard to get permission to photograph unless you have been commissioned, or have paid for the privilege. Without permission you cannot use a tripod; therefore using medium format or 5x4 is out of the question. Because of these restrictions I shot all of these, hand-held, on 35mm.

Although many people tend to think that the Kodak colour negative film that I used here is an amateur film, I find that it has remarkably fine grain for an emulsion this fast. None of these shots were filtered on camera, but they were digitally corrected and manipulated later on by computer. Of course, to some photographers this may seem like an easy option, but it is my belief that it is the final image that counts. I always shoot with available light and always hand-held.

- Hana Iijima
- Stock
- Library
- Minolta 35mm SLR
- 28 - 70 mm
- Kodak Royal Gold 400
- 1/8 sec @ f/2.8
- Available light

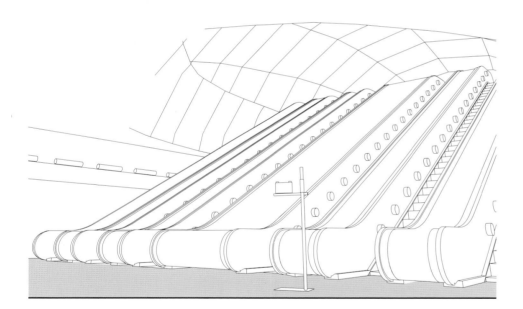

jubilee line stations london underground, uk

You don't always need expensive professional cameras to get good shots of interiors – you can get very effective results from simple, hand-held equipment, and a minimum of fuss.

This is a shot of the travelator at Munich International Airport. I had to work with available light and without a tripod, but as I was using Kodak Royal Gold 400 film, this gave me sufficient speed to be able to do this. I believe that the most important aspect of taking pictures has to be the individual form of representation you give your subject, and it is all about how you see objects and express that vision through the camera, even in restricted circumstances.

- Ⓐ Hana Iijima
- Ⓢ Stock
- Ⓛ Library
- Ⓜ Minolta
- Ⓢ 28 - 70 mm
- Ⓕ Kodak Royal Gold 400
- Ⓣ 1/8 sec @ f/2.8
- Ⓛ Available light

munich airport germany

The wide perspective, pale decor and beautiful pastel lighting combine to create a bright, airy image.

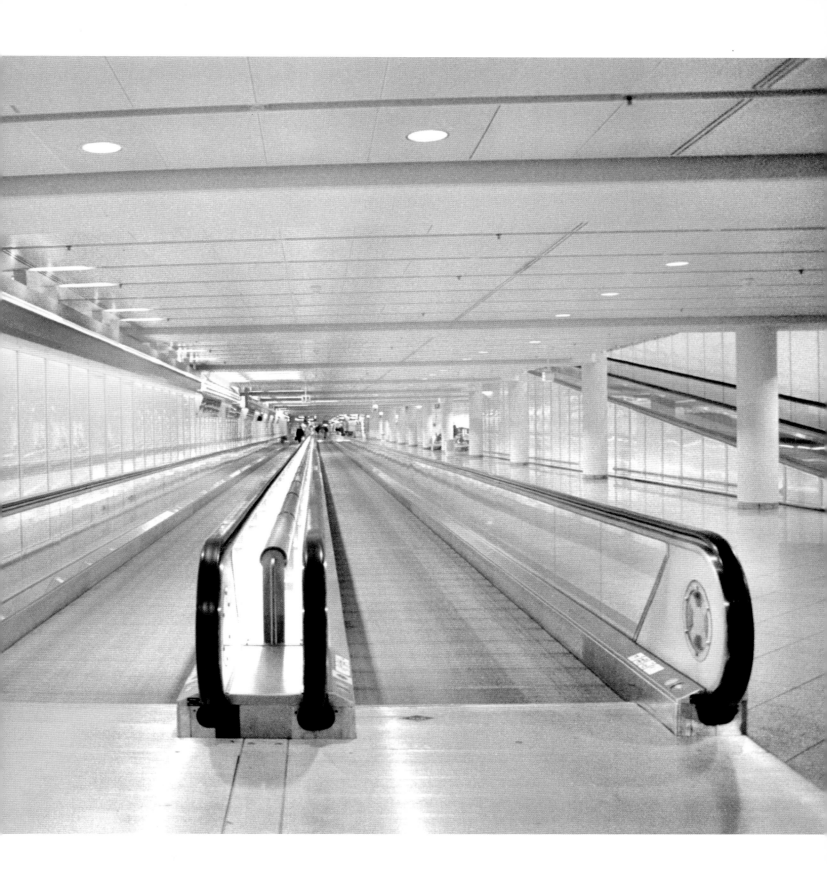

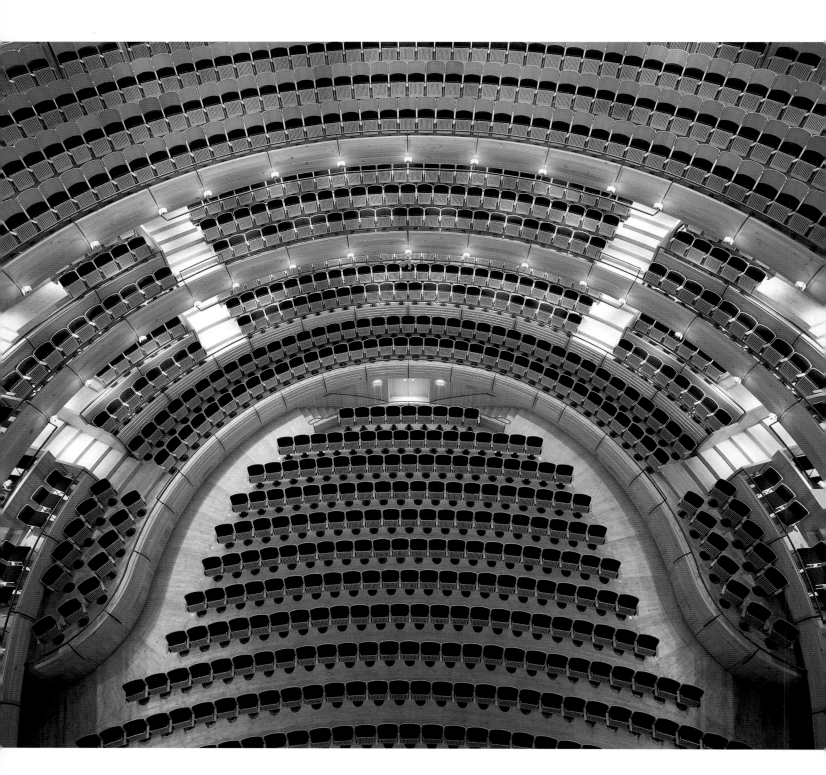

This is not the type of photograph to attempt if you suffer from vertigo. I was precariously balanced on a lighting gantry high above the auditorium. The first thing I had to do was secure the camera to the rails of the gantry so that it would not topple over and either injure someone or damage the seats below, let alone what might happen to the equipment itself! Once secured, I made sure that the camera was completely level and centred. I felt sure that the key to making this a great shot was to have perfect symmetry. Fortunately, I had an assistant who checked thoroughly that all the seats were in the same position and that all the house lights were on. The lighting designer had obviously done a good job as the lighting levels were amazingly even. Having got the shot how I wanted it and done a Polaroid, I decided that the lighting was just a little on the warm side and I elected to use an 80B filter to cool it down. The final result, from this angle, takes on the appearance of looking inside a keyboard instrument.

Richard Davies
Editorial
Book
Sinar P 5x4
75mm
Kodak EPY
40 secs @ f/22
Tungsten

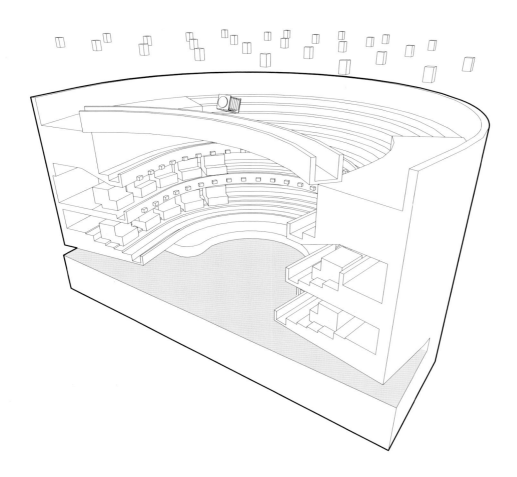

glyndebourne sussex, uk

Careful preparation is paramount for a shot like this one. If a single seat had been out of place the entire effect would have been ruined.

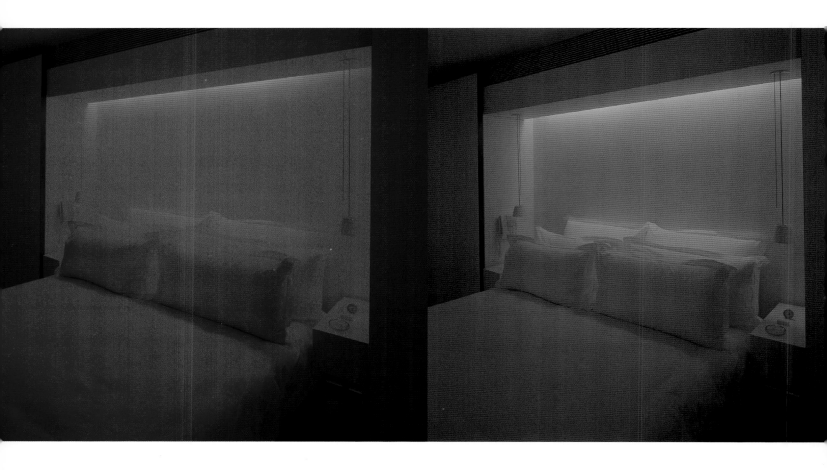

saint martin's hotel london, uk

Colour film is more sensitive to some colours of the spectrum than to others.

The bedroom in this hotel had its own adjustable lighting, in colour as well as intensity. I thought it would look effective if I shot it in the full range of these colours and then presented the shot as one. I closed the curtains so that all the daylight was blocked out, as I didn't want it to cause a colour cast. Because I was using tungsten balanced film, this cast would have been blue. At first, it might appear as if all I had to do was change the colour and shoot. However, each time I changed the effect I discovered that I had to alter the exposure, with the longest being given to the red and the shortest to the blue.

Richard Davies
Editorial
Magazine
Hasselblad Flex Body
45mm
Kodak EPY
Various, between 3–7 secs @ f/16
Tungsten

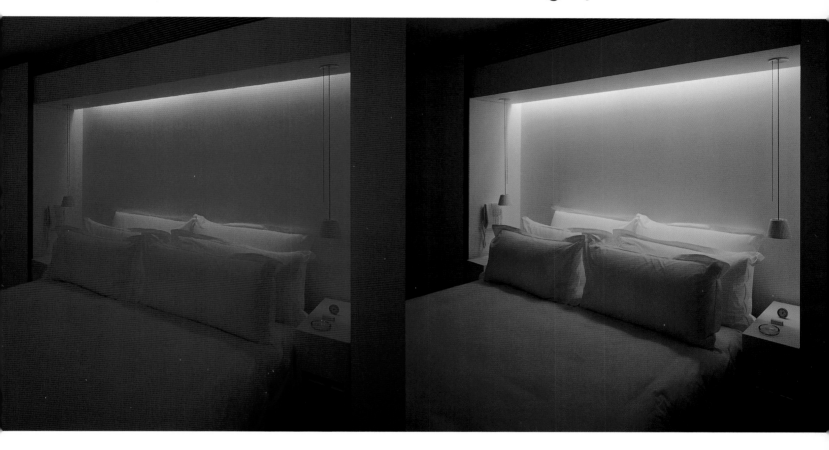

67

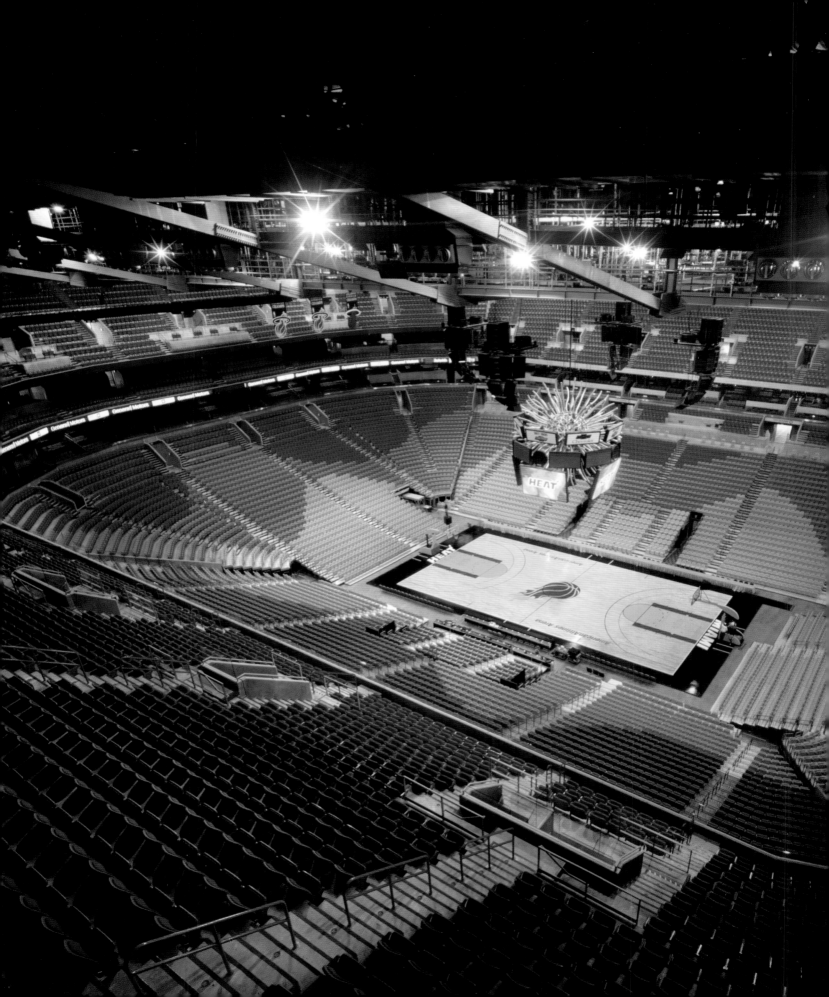

This image, of a sports stadium in Miami, was a surprisingly simple shot to take. It was taken using an extremely wide-angle lens – 58mm on a 5"x4" camera. The arena lights were very well balanced for daylight, and they only needed minor filtration of perhaps 5 or 10 magenta.

- (👤) Richard Bryant
- (👁) American Airlines Arena (architect: Arquitectonica)
- (◈) Editorial
- (▣) Linhof Technikardan 5x4
- (◉) 58mm Super Angulon XL
- (▦) Kodak Ektachrome EPN
- (⏱) 5 secs @ f/22
- (💡) Electronic flash

american airlines arena miami, usa

When shooting interiors, size is no indication of complexity. Sometimes the biggest subjects are the simplest to shoot.

This interior space was lit only by the fluorescent tubes above. Through the viewing gallery windows off to the right, another space is just visible, which has a slight pink cast to it. This space is lit mainly by daylight, and during a brighter time of the day, would have thrown more light into our space, producing a similar pink colour cast on a greater part of the photo. But on this particular dull day no light was thrown into our main space through these windows. Filters were therefore chosen to compensate for the green-blue hue of the lights in the room before us.

Nicholas Kane
Corporate
Magazine
Sinar P 5x4
90mm (+ 10 mag, blue 82B filters)
Fuji RDP II
18 secs @ f/22.5
Flourescent tubes

70 **tate modern** london, uk

Fluorescent tubes can be amongst the most difficult light sources to correct for, since their colour can vary greatly.

The extremely low lighting levels in the Lowry main auditorium gave me a particular problem. Long exposures, with the resulting reciprocity failure, made life very difficult – especially as the theatre technicians were busily preparing for a rehearsal. The ambient light was tungsten with some fluorescent house lights near the ceiling which we could not turn off. I decided to shoot for the tungsten in the full knowledge that the small amount of fluorescent would go an interesting shade of cyan. The exposures ran to two minutes with excellent results.

- Richard Bryant
- Michael Wilford & Partners
- Editorial
- Linhof Technikardan 5x4
- 90mm Super Angulon, 10 magenta and 81 cyan
- Fuji RTP
- 80 secs @ f/22
- Tungsten and fluorescent

auditorium, lowry arts centre salford, uk

The brightly lit stage in this shot appears to float in a sea of black space, creating a slightly surreal appearance.

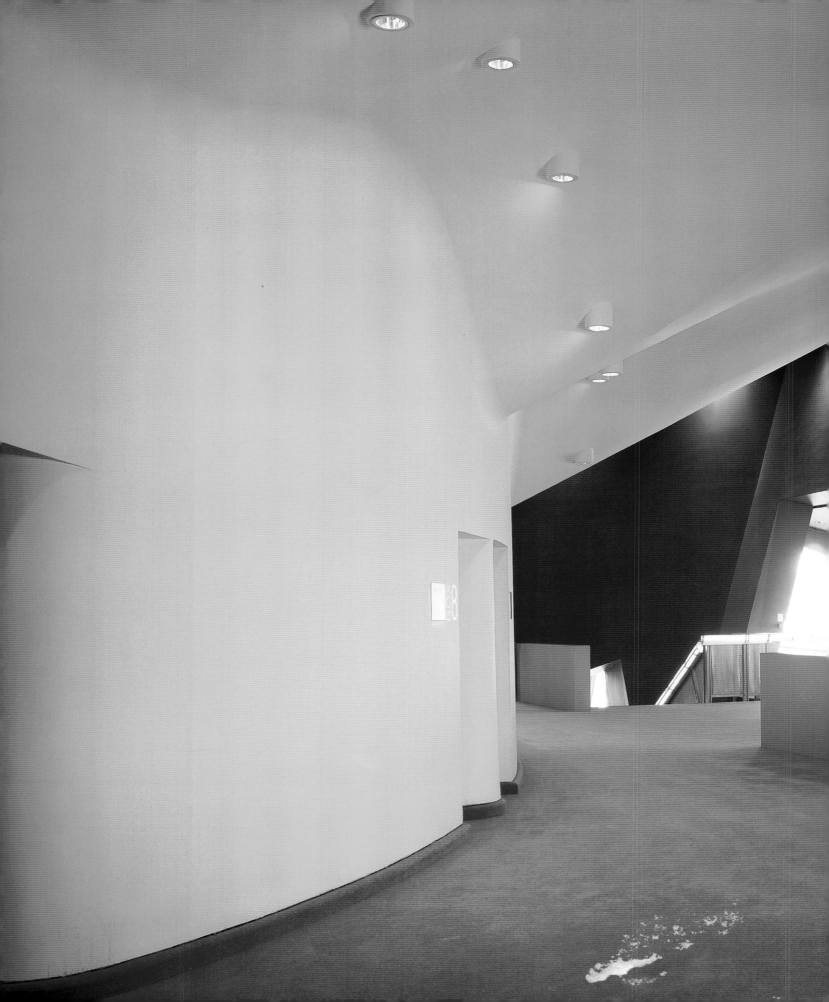

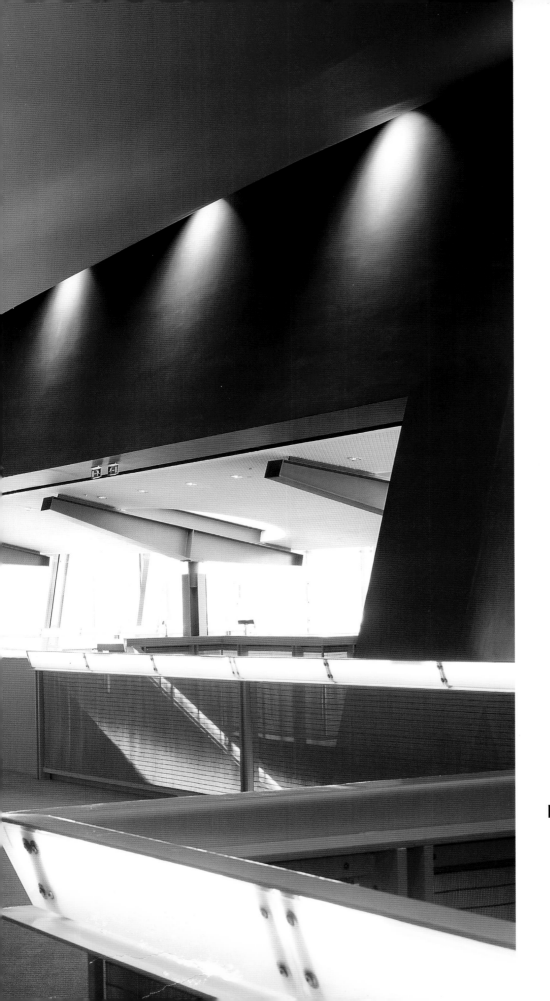

mixed lighting

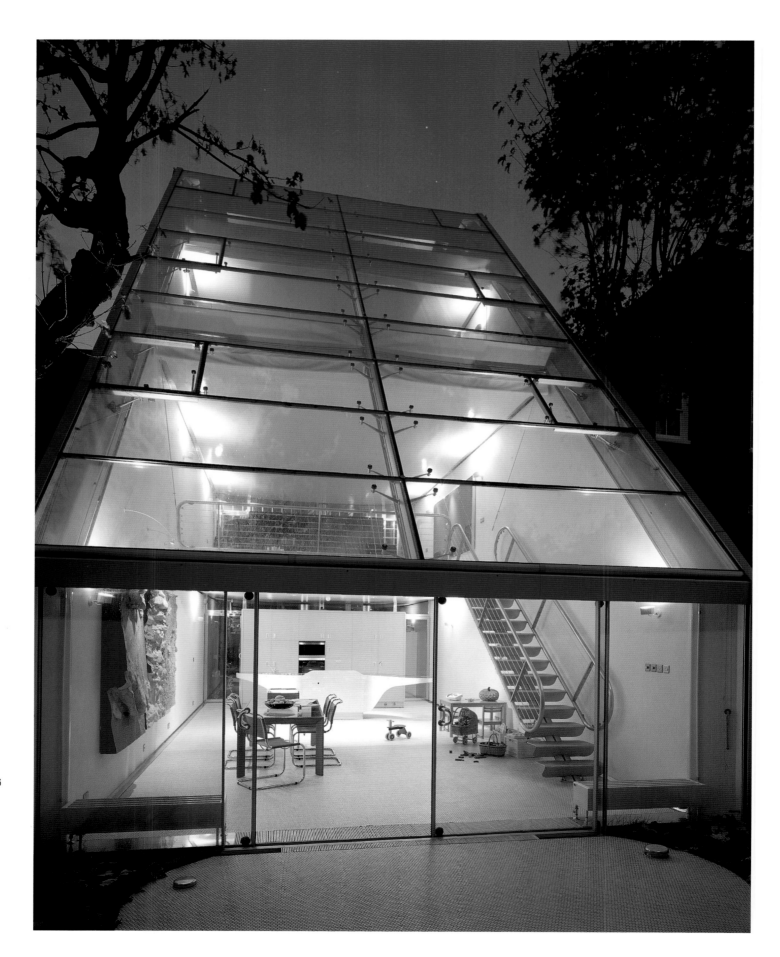

I always new that the time to shoot this house for greatest dramatic effect would be at twilight. This is when the sky takes on that wonderful cobalt blue colour. It seemed obvious to me that I would light the house with its own domestic lighting and therefore switched on all the available lights I could find. I chose Kodak EPY film to balance with these lights, while at the same time I knew that the sky would go even bluer. Although it looks easy, there is a definite point at this period of the evening when the hue of the sky is at its optimum in terms of getting the best colour. I therefore made sure that I was set up and ready to shoot well before the sky got darker and dusk set in.

The lights inside the house were surprisingly even and all had the same colour balance. Those that needed adjusting in intensity were controlled by dimmer switches. Once I felt that the light was right, I exposed several sheets of film over a period of about five minutes.

Richard Davies
Editorial
Book
Sinar P 5x4
90mm
Kodak EPY
10 secs @ f/22
Daylight and tungsten

glass house london, uk

This is a rare example of being able to photograph an interior from the outside!

It is not uncommon for someone to say: "Well, you can't go wrong there" – meaning that you could plonk the camera anywhere and you would make a great picture. This is not something one wants to hear – ever – but this was one of those places... There were clearly several good shots in this atrium, and I spent some time looking at the staircase from all levels. This view is from the top of the building, just below the roof-light, and I chose to shoot it on a dull day, as direct sunlight coming from above would have made it look like a cave. There is fluorescent light spilling out from the walkways (hence the green cast to the floors) and tungsten in the basement café area. I decided to correct only the daylight (97.5M + 81 on the camera) which took care of the glass in the atrium roof. We spent some time arranging the tables in the basement café, and then all there was to do was hang the camera off a boom arm on the tripod, so that the picture would consist of only the staircases, avoiding any of the surrounding walkways.

Dennis Gilbert
Architect: Wingardh Sandell Sandberg
Editorial
Linhof Technikardan 4x5
120mm, with 7.5 magenta + 81 filters
Fuji Provia 100
11 secs @ f/32
Daylight fluorescent + tungsten

offices london, uk

It may seem like you can't go wrong with such a photogenic location, but it's still worth exploring all the possible viewpoints.

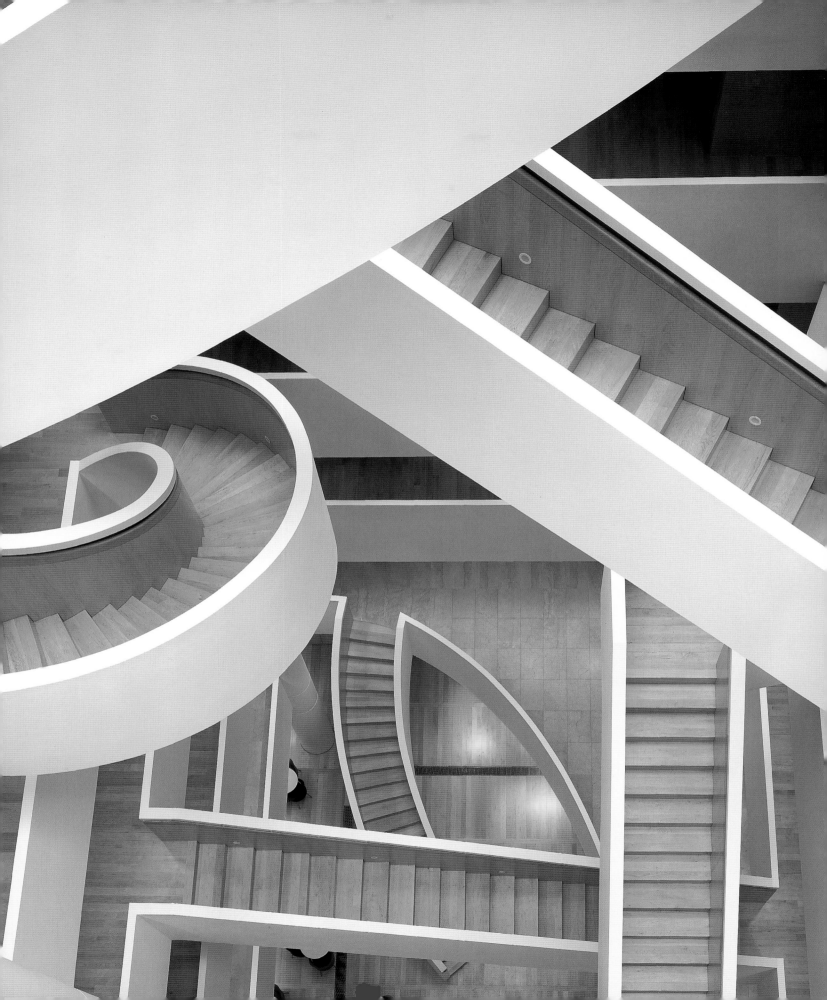

Norman Foster, the most generous of architect commissioners, sent 6 photographers to shoot the Reichstag building during the weeks either side of its opening to the public. Some had specific assignments, but there was still a danger of tripping over another's tripod! For the main shot (right), I needed no tripod: I taped the lens face down to the sloping glass above the parliament chamber and then attached the camera. I had two goes at this – the first on a dreary day, when I was trying to find something useful to do. I then wanted to repeat it on a sunny day, so I could capture the shards of reflected light from the mirrors into the dome. By this time, the building had opened and I was in the process of kneeling on the glass roof with a cloth over my head when the public began to arrive – and the police quietly ushered me away before I could finish. It was third time lucky, when I returned with a prearranged escort. I had a picture, which I could barely imagine would succeed when I began the process. The chamber is lit by tungsten, plus reflected daylight from above, so I went without filtration, reckoning that any green in the glazing would not harm the tungsten, which can tend slightly towards magenta in the film I use.

The general view (bottom right), showing the re-created eagle and the chamber, with its members at work, suggests the quality of light and space that a Foster-designed building typifies. The detail of the eagle wing was taken with a 210mm lens and was taken from outside the chamber looking through the glazed wall.

Dennis Gilbert
Architect: Fosters and Partners
Editorial
Linhof Technikardan 4x5
90mm
Fuji 64T
18 secs @ f/22
Daylight and tungsten

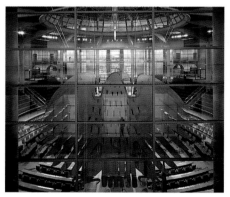

the reichstag berlin, germany

Subjects as visually striking as the German parliament building offer numerous picture possibilities.

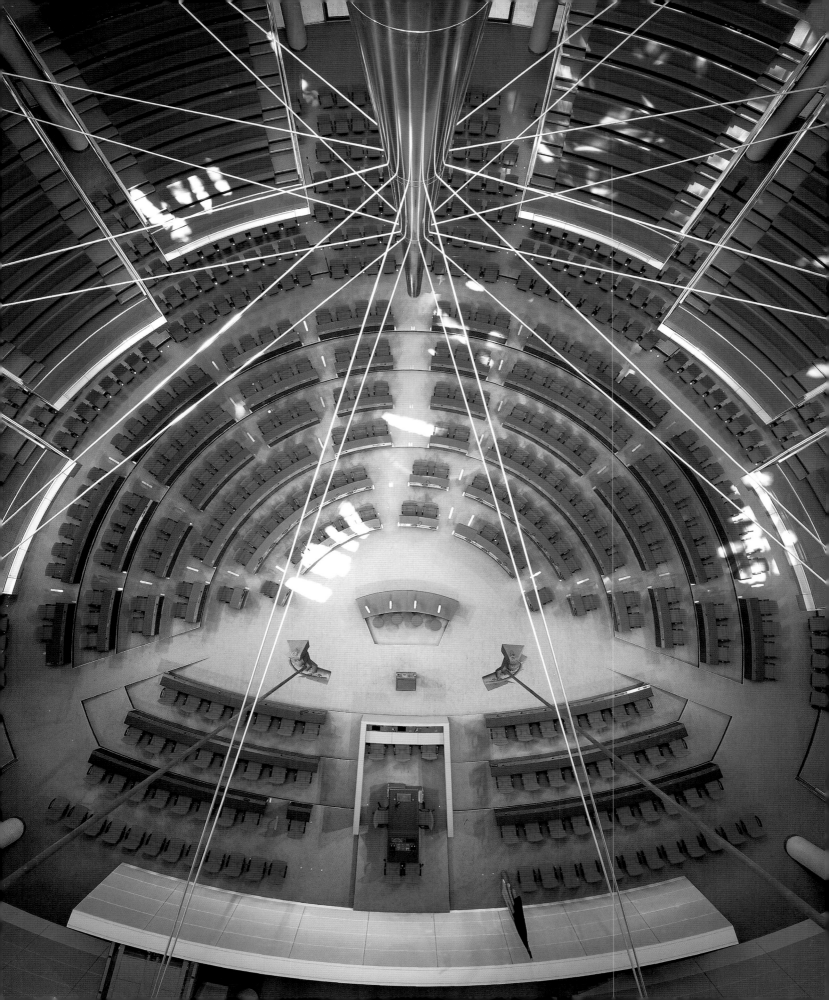

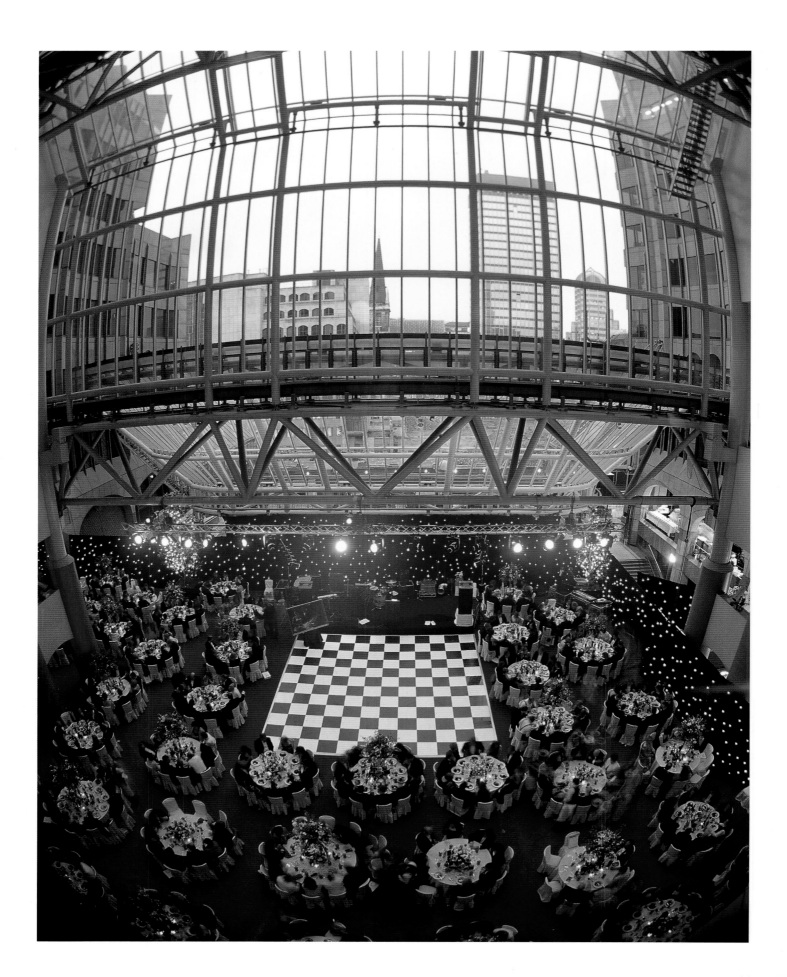

The difficulty of a shot like this, is the lack of time in which to shoot it. Commissioned by a design company and event organizer, I was asked to photograph the installation they had created of a corporate dinner for 700 guests. I could not start shooting until the last flower, table setting and chair had been arranged and the floor swept. By this time the first guests where arriving and I had to work quickly to get as much shot as possible.

I ascertained that I would have to shoot in available light, which in the early summer evening would be daylight. Fortunately, this proved to be very even and was coming through the glass roof of the atrium in the office building. Several shots were completed including details. Many of these had to be 'tweaked' as there was always something out of place. Having got these shots, I then went to the seventh floor and chose a fish-eye lens as an alternative to the more formal shots I'd just done. This time, I was working with constantly changing disco lights as well as daylight. However, this worked well because the mix created a less rigid atmosphere and captured the ambience of the event.

(👤) John Freeman
(↺) Corporate
(◈) Brochure
(📷) Mamiya RZ67
(◉) Fish-eye
(▶) Kodak EPP
(🕐) 2 secs @ f/11
(💡) Daylight plus tungsten

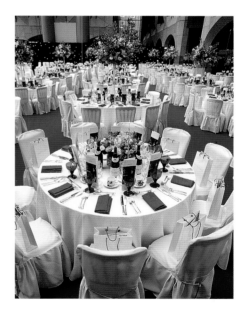

mitre house london, uk

Sometimes it is necessary to be able to work quickly and produce a variety of images in a short period of time.

This building overlooks the sea in a perfect location, and I planned a picture that would emphasise the lightness of the tensile structure and materials, and also use the view beyond as a distant attraction. To maintain the intent, we moved the ubiquitous plants, coat racks, bins and other undesirables to the fringes, and tidied all the tables. The interior metal halide lighting required 10M filtration on the camera, which did not affect the blue dusk light beyond.

- Dennis Gilbert
- Architect: Michael Hopkins and Partners
- Editorial
- Linhof Technikardan 4x5
- 120mm, 10 magenta filtration
- Fuji Provia 100
- 16 secs @ f/22
- Daylight, plus metal halide lighting

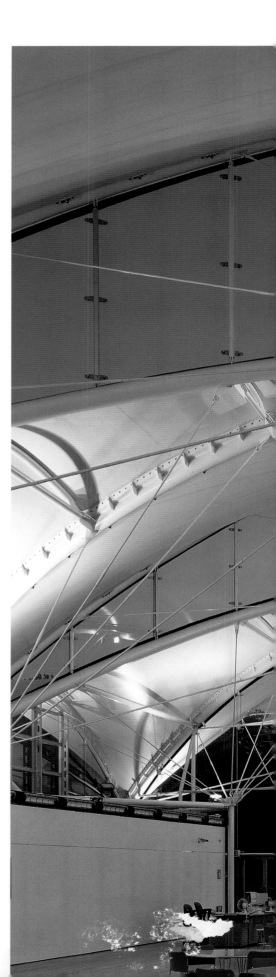

84

saga headquarters folkestone, uk

"I planned a picture that would emphasise the lightness of the tensile structure and materials, and also use the view beyond as a distant attraction."

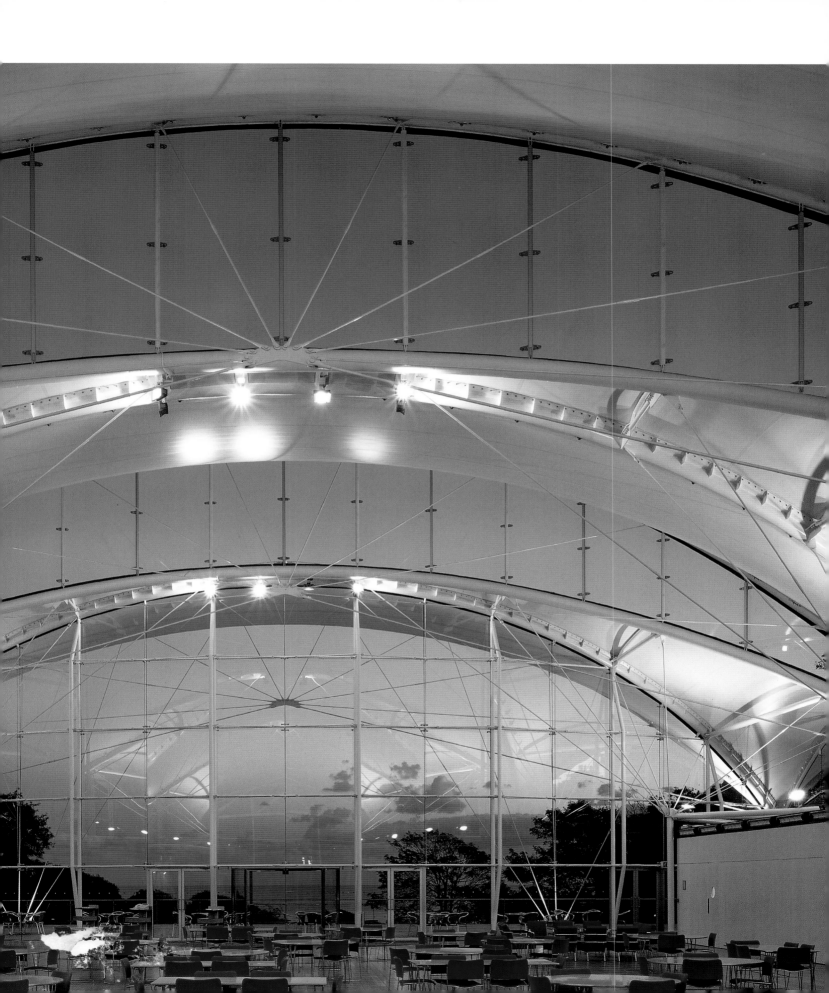

The saturated colours in this composition were irresistible, but made it very difficult to assess the filtration required for a correct rendition. The reflections from the walls and carpet almost caused the colour meter to overload. However, with some interpretation, I decided to put some heavy blue filtration in the camera and for once cover myself by shooting on daylight film, and then, with very little filtration on Tungsten film. The fluorescent-lit handrails caused surprisingly no problems, with a 10 magenta added. Exposures were rather lengthy at 16 and 20 seconds.

Richard Bryant
Michael Wilford & Partners
Editorial
Linhof Technikardan
120mm Super Angulon
Fuji RDP
16 secs @ f/22
Daylight, tungsten and fluorescent

lowry arts centre salford, uk

This extremely yellow interior required heavy blue filtration.

86

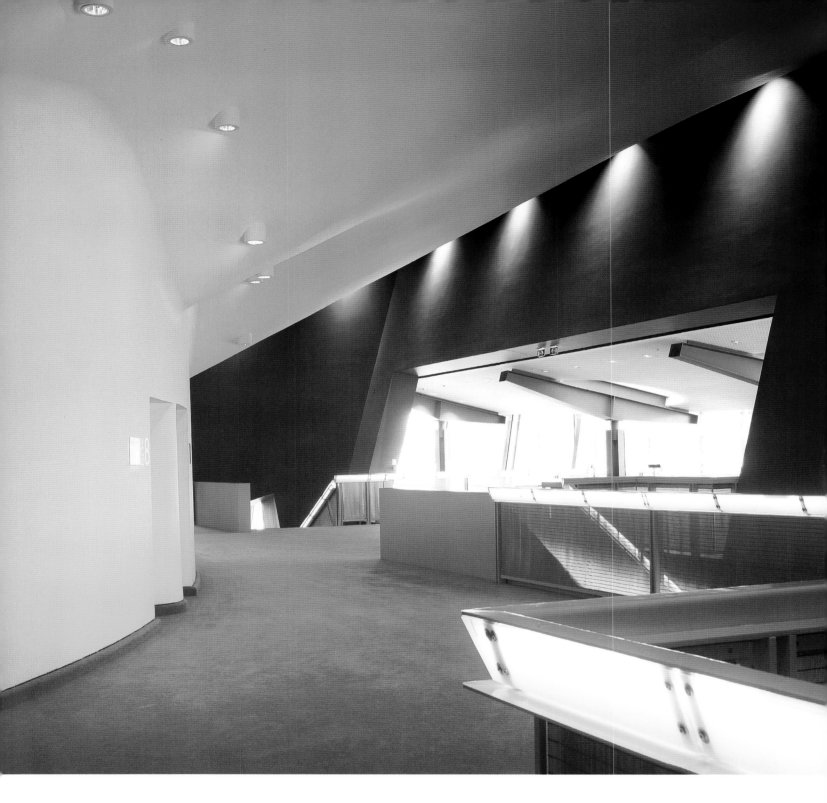

Working for Zumtobel is quite a challenge. The buildings and interiors are of the highest architectural quality, colour accuracy is of the essence and I am usually shooting under complex mixed lighting conditions. In this instance the set up included daylight, neon, fluorescent, and tungsten lights. The discontinuous lights were state of the art and like no others I had encountered before.

The sunlight version (below) was comparatively simple. I used a small amount of fill-in flash, and the only other adjustment necessary was the slight correction required to the warm winter light. The colour meter suggested adding cyan and a little magenta. This proved correct. In the twilight condition (main picture), more magenta was added to compensate for the higher levels of discontinuous light, and with the added problem of a continuously cycling blue neon in the foreground, the exposures had to be timed precisely. A 240mm lens kept the composition tight on 5 x 4. Fuji daylight film proved to be the best choice for the sunlight version and Ektachrome for the artificial light.

Richard Bryant
Corporate
Editorial
Linhof Technikardan 5x4
240mm, cyan and magenta
Kodak Ektachrome EPN
5 secs @ f/32
Daylight, fluorescent and tungsten

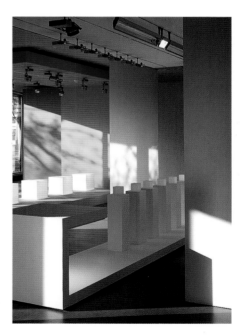

zumtobel showroom zurich, switzerland

Complex mixed lighting situations can be a challenge. A colour meter can be an invaluable aid to deciding upon the appropriate filtration to correct colour casts in the scene.

This building was lit at night with a vibrant range of colours varying from red at the base through to pale yellow at the top. I noticed this dramatic view from the inside at twilight. The crucial moment when the exterior light matched the building lights in terms of intensity, only lasted for a few minutes. I therefore prepared the composition beforehand in order to be ready for that "right moment".

Daylight film was appropriately filtered for the discontinuous building lights and I used a fairly wide-angle lens (72mm). I normally filter on the rear of the lens to reduce the possibility of flare and double imaging, however, in this case, with such a wide-angle lens, the standards were so close together that this was not possible. Because the lens was so wide-angle and the main subject, the fenestration, was in one plane, it was not necessary to stop down beyond f/16, which meant that the exposure was comparatively short.

Richard Bryant
American Airline Arena (architect: Arquitectonica)
Corporate
Linhof Tecknikardan 4x5
72mm Super Angulon XL
Fuji RDP III
2 secs @ f/16
Available light

window, american airlines arena miami, usa

When the subject is a window, balancing the interior light level to match the intensity of the exterior light can be tricky, but is worth the effort.

ⓧ Dennis Gilbert
◔ Architect: John Pawson
◉ Editorial
▥ Linhof Technikardan 4x5
◉ 210mm with 15 magenta filter
▣ Fuji Provia 100
◷ 6 secs @ f/16
◔ Daylight, fluorescent and discharge lamps

cathay pacific lounge hong kong airport

92

Adding people to a scene can, if carefully placed, add life to a photograph.

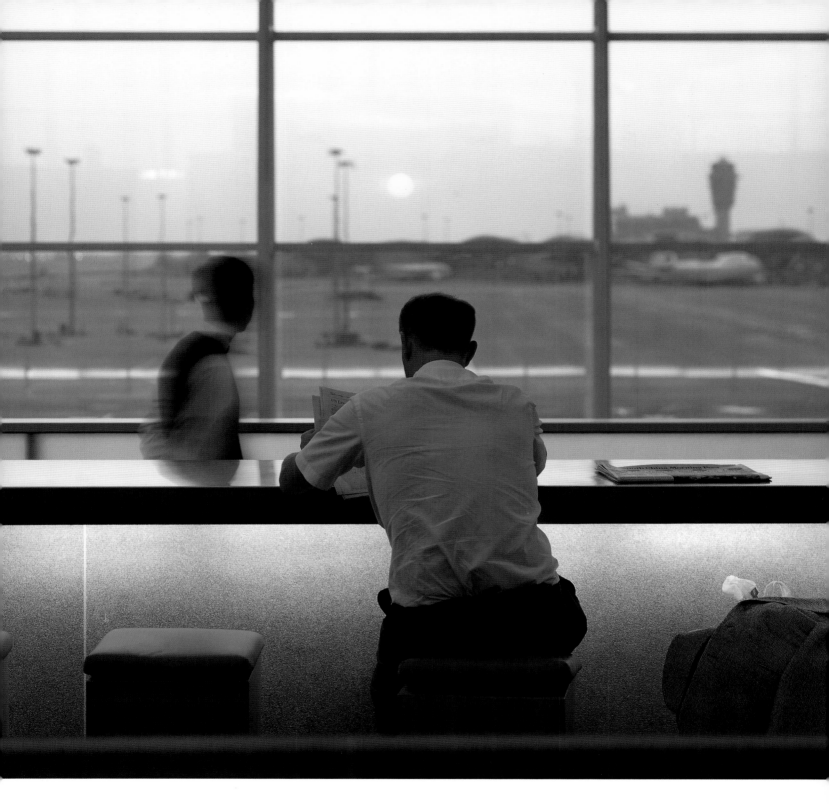

Photographing a working airline lounge naturally meant that there was no control over the light balance, and compromises had to be made. Fortunately, I had already shot the airport and knew the conditions for evening operation. The main bar is an elegantly simple, long steel structure. Daylight needed to be slightly more dominant to keep the eye moving out and then back in again. There were fluorescent lamps under the counter and the general airport lighting required about 10M, so I decided to put 15M on the camera, which would take some of the green from the counter lights without causing an unreal shade of pink in the daylight.

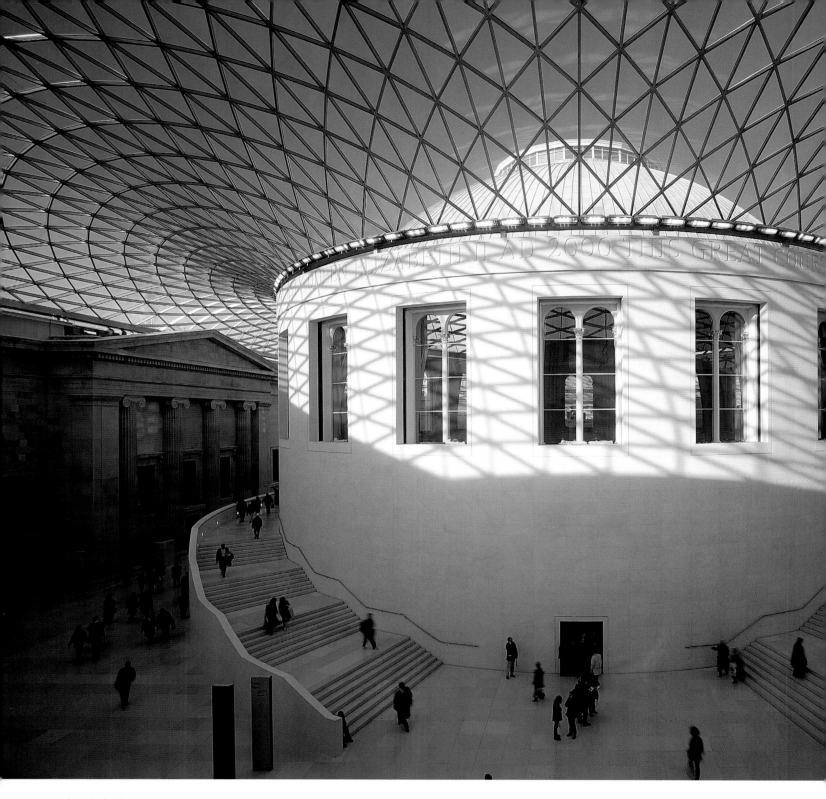

british museum london, uk

Graduated filters are useful for correcting imbalances in brightness between the top and bottom parts of a scene.

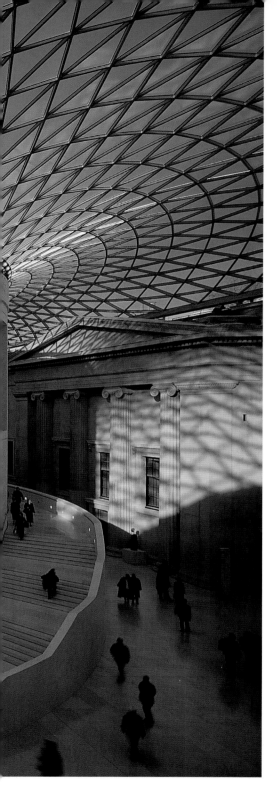

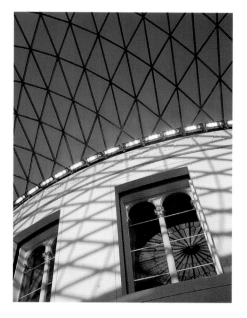

Although no additional lighting was used for this shot, the colour correction proved to be quite a problem. Not only were there very powerful discontinuous lights running around the drum, but the fritted roof glass was the greenest I had ever encountered. This required heavy magenta filtration.

The 58mm XL lens on 5 x 4 gave an almost panoramic effect with very little distortion due to the axial viewpoint. Moreover, the exposure had to be judged exactly, to cope with the extreme contrast from bright sunlight to deep shadow. A graduated filter was employed to help with the contrast. Due to the short focal length of the lens, a short exposure could be used at f/11 without losing much depth of field.

Richard Bryant
Norman Foster & Partners
Editorial
Linhof Technikardan
58mm XL
Kodak Ektachrome EPN
4 secs @ f/22
Available light

- Niall Clutton
- Corporate
- Brochure
- Linhof Technikardan
- 150mm
- Fuji RTP 5x4
- 30 secs @ f/32
- 6 arrilight 800s + 4 strand bambino fresnels

It is essential to preserve the mood of the space, whilst adding creative lighting to keep detail in the shadows, and without burning out all those white linen table cloths. In this shot for Gordon Ramsay at Claridges, the whole scene is tungsten-lit predominantly towards the camera, with a limited amount of soft-fill from the front. This puts crisp highlights on the linen and glassware, and gives detail in the darker chair backs and carpet. I placed the lights carefully to avoid casting shadows from the enormous lampshades that hang from the ceiling.

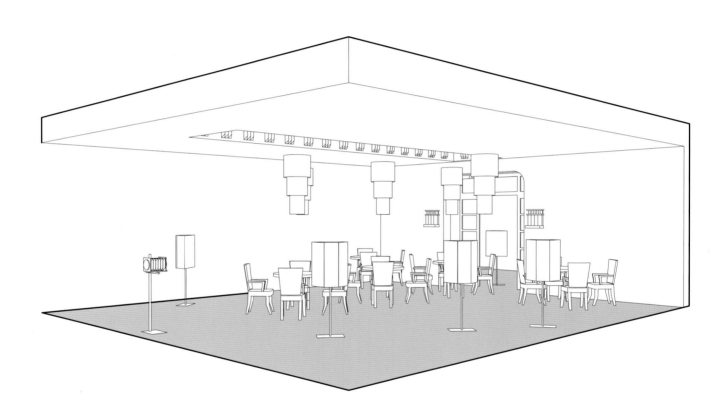

gordon ramsay restaurant, claridges london ,uk

Lighting restaurants for interior shots is a balancing act.

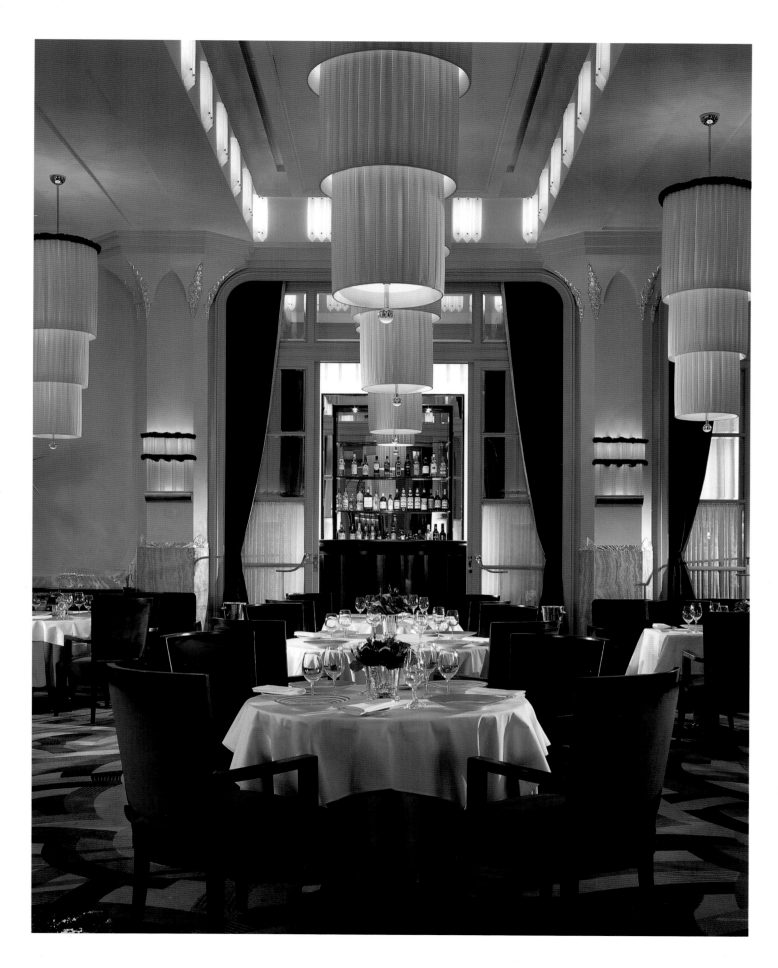

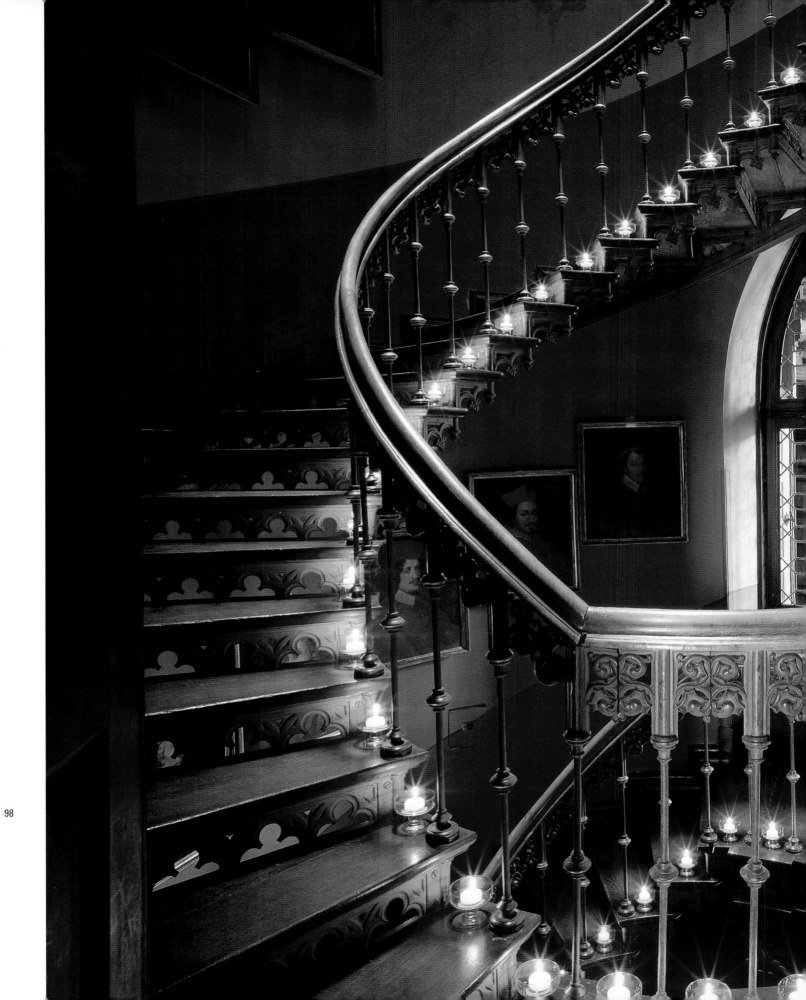

I took this shot using just the light coming from the candles and the small amount of daylight coming in through the doors on the landing. I calculated the exposure so that the room, which is visible through the doors, did not burn out. If this had been the case, then the whole atmosphere of the shot would have been lost.

Fritz von der Schulenburg
Editorial
Book
Hasselblad SWC
38mm
Kodak EPP
60 secs @ f/11
Daylight and candles

candle staircase hannover, germany

A long exposure was required to capture the atmosphere created by the candles.

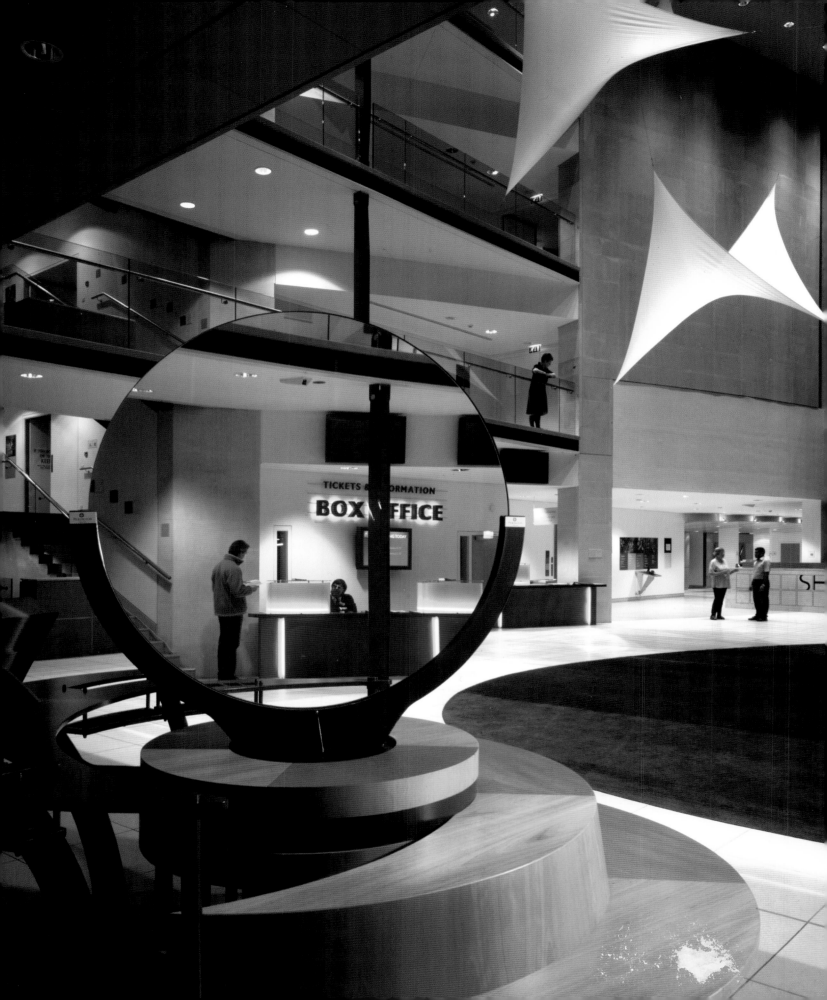

This image was taken as part of an assignment to photograph the whole of The National Museum of Photography, Film and Television for The Architects' Journal. This particular picture was destined to be the issue cover and was taken in the museum foyer. The problem with most architectural images is in dealing with mixed lighting that buildings so often have installed. The foyer was in a north-lit atrium and shot in winter, so there was no chance of direct sunlight to liven the scene. I opted for shooting after dark, to eliminate the flat-blue light quality emitted in the daytime, and to work instead with the fluorescent, neon and metal halide fittings. I chose to place "the world's biggest lens" in the foreground, which in turn gave a slightly enlarged view of the scene beyond it. This needed lighting and I used an Arri blond 2k tungstem lamp, gelled from its 3200 kelvin up to approx 4500K green. This matched it to the ambient green cast. I then lit the people in the background with a Larn Softlight, again gelled to match the fluorescent around it.

I took the whole scene back to daylight temperature with a 30cc magenta filter on the camera lens and shot with a 90mm Super Angulon lens using a considerably large amount of rising front. I had to let the balconies go slightly green as I couldn't risk the main area of the shot appearing pink, a problem which would have occured if I had over-compensated with too much magenta filtering. If one has a single light source type with one single lamp type, the filtering can be accurate, but I was faced with a mixture which had to be "averaged". The metal halide is never as strong in cast as compact fluorescents and given that it was the dominant source in the atrium space, this is what I had to match. The result is certainly colourful.

Martine Hamilton Knight
Editorial
Magazine
Linhof Technikardan 45
Scheider 90mm Super Angulon
Fuji Provia II
f22 @ 12 seconds
Tungsten and fluorescent

national museum of photography, film & tv bradford, uk

The photographer cleverly used a giant magnifying lens in the museum foyer to great compositional effect.

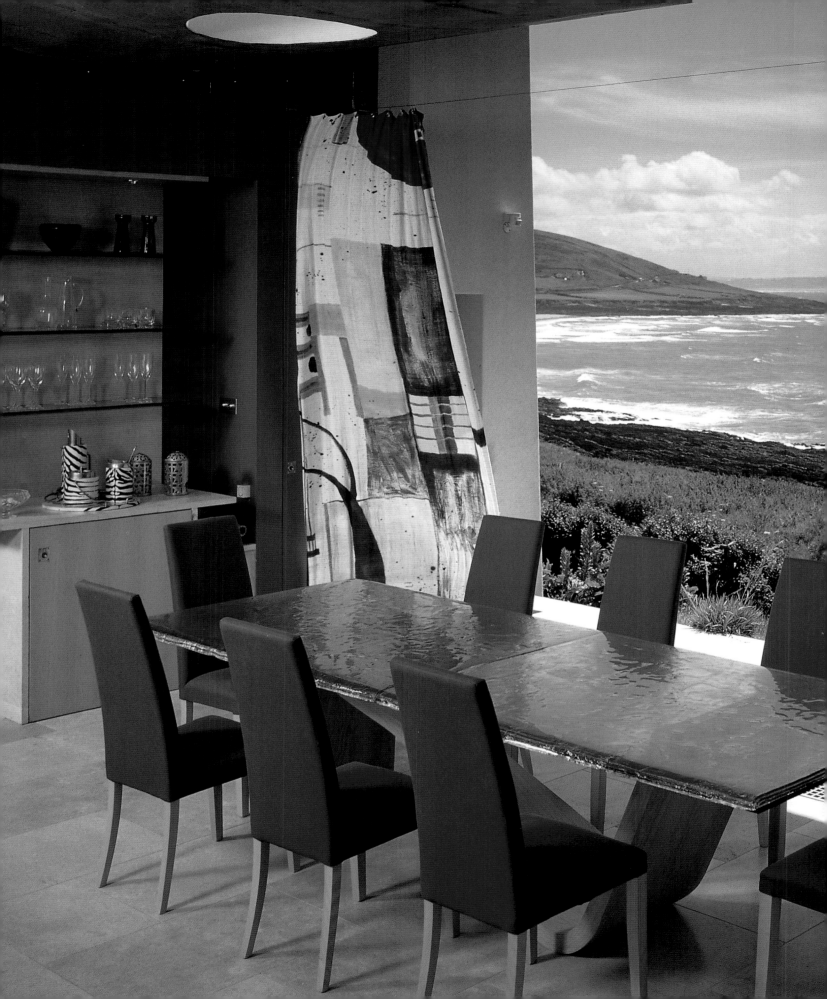

adding light:
simple setups

104

I found this heavily carved door, which contrasted strongly with the elegant Brancusi like steel sculptures in the alcoves, extremely attractive. The only available light was the tungsten light in the alcove. The dark wooden door absorbed light to an incredible degree and needed 2 flashes on full power from my Elinchrom 1500 pack. This amount of power was essential for the door carvings to register; if they hadn't, this would have left the steel sculptures extremely stark. Because of this, I made the decision to let them be lit by the alcove lights alone for 6 seconds to give them a more dramatic feel.

Tim Beddow
Editorial
Book
Mamiya RB67
90mm
Kodak EPP 120
6 secs @ f/11
Flash and tungsten

entrance door of a lodge botswana

The dark wooden door absorbed light to an incredible degree and needed 2 flashes on full power.

This bedroom belonged to a lodge in Northern Botswana. Although it appears to have a strange perspective, it was taken on a Mamiya RB67 with a 65mm lens, which is not excessively wide-angle. The extremely large frame around the bed is responsible for the unusual shape. Behind the bed is the bathroom, with doors leading onto the garden. African light can be very strong so any views looking out of windows or doors need additional light to prevent burn-out. I placed 2 Elinchrom heads on either side of the camera and one in the bathroom, with reflectors, to prevent the greenery from burning out. I also had to slightly open the far window so that the camera and the lights did not reflect into it.

For the second bedroom shot (below), I went for more of an evening feel, by keeping the lamps on for 2 or 3 seconds, drawing the mosquito nets and turning down the beds. Flash was still required to keep an acceptable balance.

(🚶) Tim Beddow
(↩) Editorial
(◈) Magazine
(📷) Mamiya RB67
(◎) 65mm
(▣) Kodak EPP 120
(⏱) 1 sec @ f/16
(💡) Daylight and flash

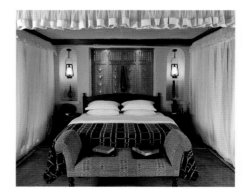

bedrooms at a lodge botswana

These pictures owe their visual appeal to the perfect symmetry of the composition.

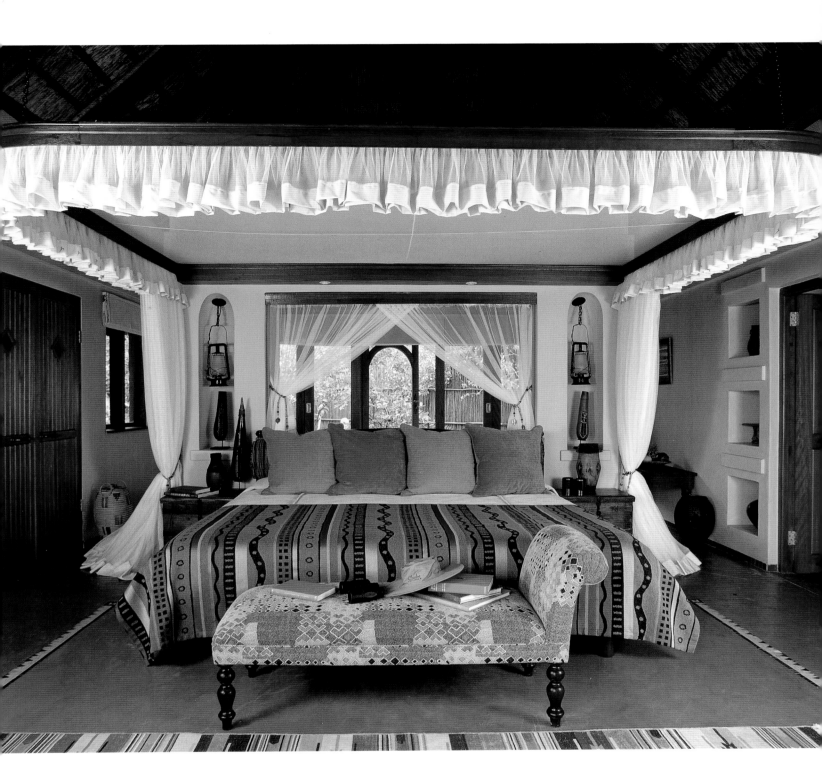

The subtle daylight filtering through the window creates the peace and tranquillity that comes across in this shot. However, there is also a certain amount of flash filling in the shadow areas. The symmetry of the room adds to its simplicity and draws the eye straight into the picture. Having carefully positioned the camera so that it did not reflect in the window, I placed a Broncolor head to the right of the camera. To this, I fitted a silver brolly, again taking care that it did not reflect in the window. I did not want to overlight the room but the wall behind the two lamps just needed a lift. At the same time, it was important to retain the shadow detail of the table and chairs falling on the floor. This is the key to a good interior shot: a feeling that it is just lit with natural light when the truth couldn't be more different. The view outside the window was slightly overexposed for two reasons: the first was to obscure some unwanted detail and the second was to make the day look more sunny than it actually was.

Andreas Von Einsiedel
Editorial
Magazine
Hasselblad
50mm
Kodak EPP
1/2 sec @ f/11
Daylight and flash

108 # domestic interior london, uk

The key to a well-lit interior shot is to create the impression that it is lit only with natural light – even if it isn't.

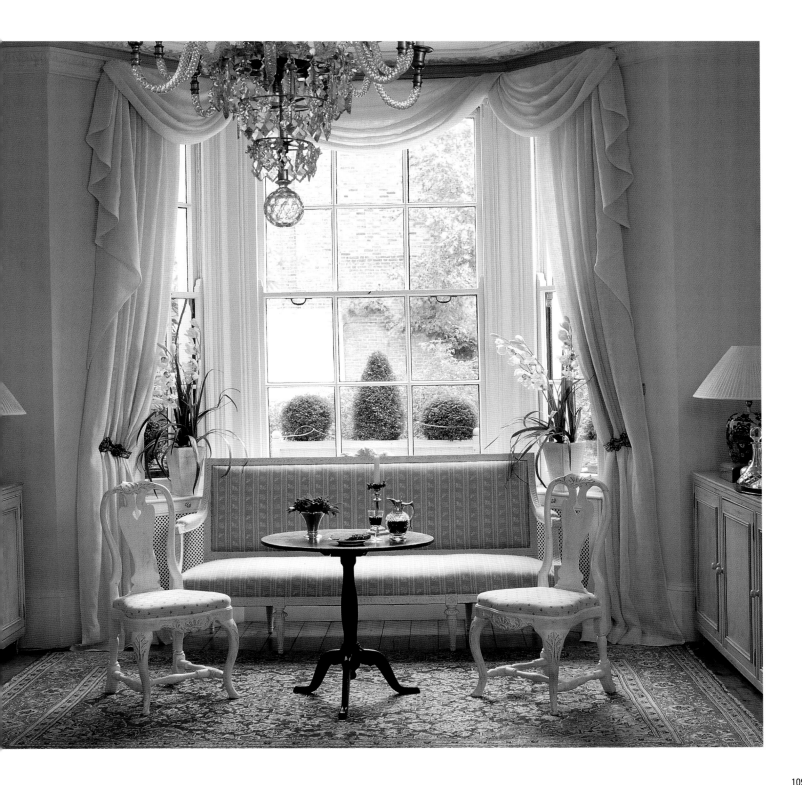

In the shot of the hallway (main image), the circular glass block wall made a perfect diffuser for my lights. After selecting my camera position, I placed one redhead behind the wall to my left and adjusted it until the light pattern gave the desired effect. I placed another on the top landing to keep the illumination even. The doors to my left picked up enough ambient light to give enough exposure. I adjusted the down lighters with their dimmer switches until the balance was just right. The patterns cast by the glass blocks give a theatrical feel to the shot and the redheads proved much more effective than I feel flash would have done.

For the picture of the living room I wanted to keep the mood of the lighting, so I decided to supplement the available light with some redheads. The first, which was fitted with barn doors and bounced off the ceiling, was placed to the left of the alcove. Another was positioned on the landing and gave a highlight to the balustrades as well as the ceiling. The room lights were adjusted by dimmer switches until an acceptable balance was obtained. The exposure was 15 seconds.

I could have had problems with this bathroom as it was lit on the inside with tungsten lights but had a large window to the left with translucent glass that let light in but obscured any view. As it did not have any curtains or blinds, I could not block out the daylight. However, I used this to my advantage. Because I was shooting on Kodak EPY, which is balanced for tungsten light, I knew the window would go blue and therefore be harmonious with the predominately blue mosaics of the bathroom. I adjusted the down lighters using dimmer switches, then placed one redhead to the alcove on the right. I placed another beside the camera but pointing to the wall behind me, so that it would reflect in the mirror at the correct exposure and highlight more detail in that area. Finally I lit the candles besides the bath.

🔆 Richard Davies
🔆 Advertising
🔆 Architects Use
🔆 Hasselblad SWC
🔆 38mm
🔆 Kodak EPY
🔆 6 secs @ f/22
🔆 Ambient tungsten plus redheads

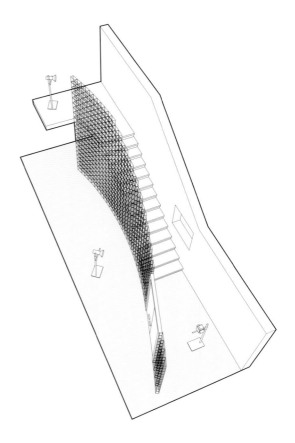

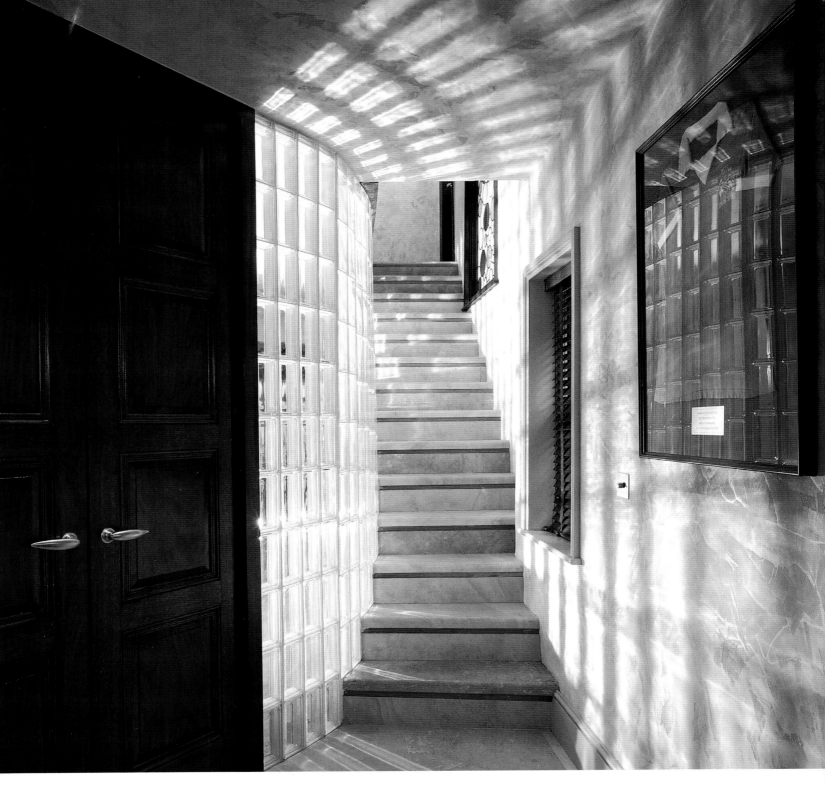

private house london, uk

This house belonged to a famous English pop star, and was full of memorabilia and classic items of furniture.

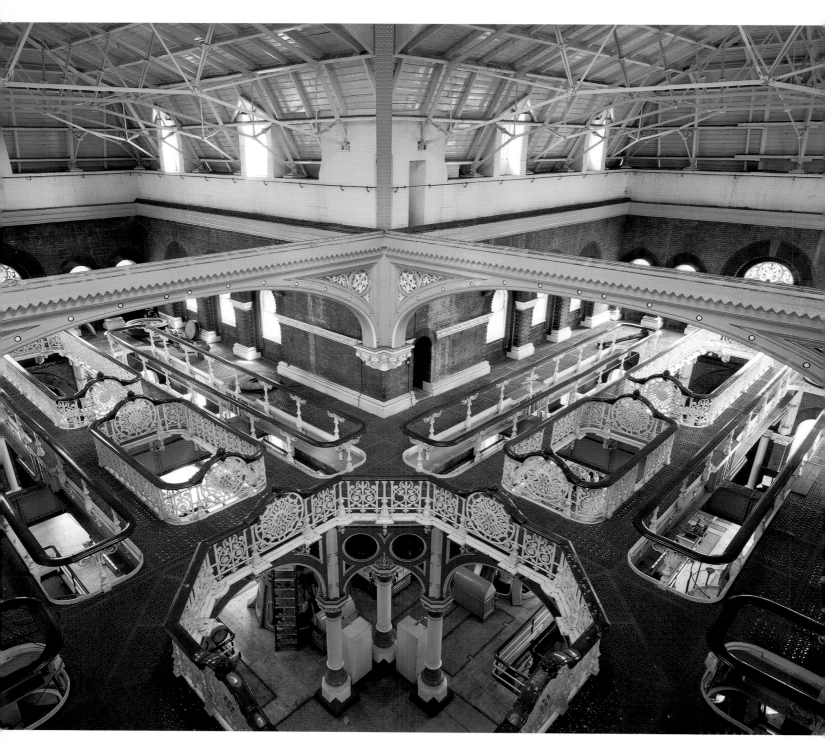

abbey mills pumping station london, uk

Careful choice of viewpoint has created a strong, graphic image.

At first, I thought that I could light this Victorian pumping station with daylight, but after choosing my viewpoint it became apparent that I would have to light the lower floor with flash. (This is the area in the immediate foreground.) Two Broncolor Pulso 8 units were positioned to illuminate this area and were fired with an infrared trigger attached to the camera. This was the only way I could fire the flash without having to use a sync lead of some 20 metres. The flash, being balanced for daylight, meant that I could use daylight balanced film without the need to either gel any lights or filter the camera. If I had not used the flash units, then this area would have been totally underexposed. On the other hand, if I had exposed for this area, then the rest of the shot would have been overexposed. When shooting buildings of this scale it is essential to achieve this balance otherwise the end result will not do justice to the surroundings.

John Freeman
Editorial
Book
Sinar P 5x4
70mm
Kodak EPP
4 secs @ f/16
Daylight and flash

This room presented two main lighting problems. The first was that the large mirror that faced the camera could have produced flare and unwanted reflections if the lights had not been positioned correctly. The second was that to get the right ambience the candles had to be lit, and therefore balanced in exposure to the flash.

My main light, a Broncolor Grafit 2 power pack with a Pulsoflex soft box, was positioned as far to the left of the camera as I could possibly get it, without it reflecting in the mirror. I used another head to the right of the camera, fitted with a honeycomb so that the light was more directional, and this was directed to the table to give just the right amount of highlights to its surface. A third light was positioned behind the camera to light the wall that was reflected in the mirror. Each light was programmed to give just the right amount of power until the correct balance was achieved and confirmed on a Polaroid. Finally, an ambient light reading was taken to ascertain the exposure required to record the candles – 2 seconds at f/11.

ⓐ Andreas Von Einsiedel
ⓢ Editorial
ⓜ Magazine
ⓗ Hasselblad
ⓛ 50mm
ⓕ Kodak EPP
ⓣ 2 secs @ f/11
ⓘ Flash and available light

114 **thierry bosquet** belgium

Placing the camera and lights must be done carefully and with consideration, when there is a large mirror in the field of view.

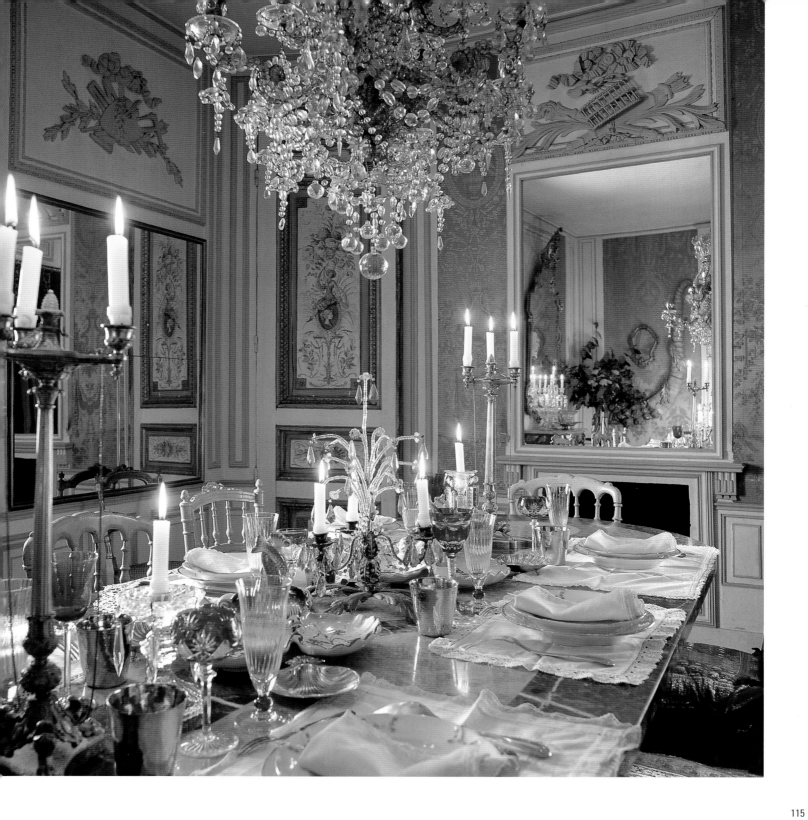

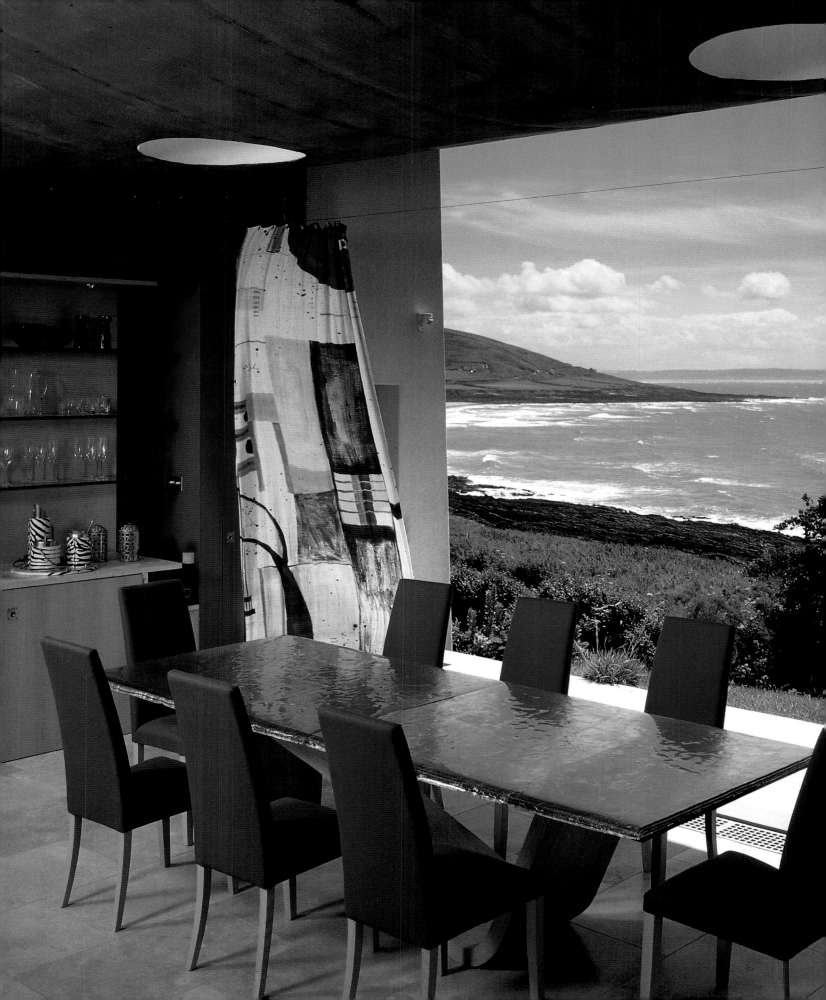

The hidden benefit of shooting this room was that the huge picture window could be lowered in its entirety into the floor. This gave the advantage of not having to worry about reflections in the glass. However, it was a particularly windy day and the gusts blew straight into the room.

The most important aspect of the shot had to be balancing the light in the room with the stunning view beyond. If the sea and sky had been overexposed, the whole impact would have been lost. To this effect, I positioned two Elinchom flash units to the left of the camera pointing toward the window wall. One of these was slightly bounced to bring out the ceiling. I used a polarising filter, to enhance the colour of the sky and the sea, and I also used a 05 magenta filter to take out the green cast. I always take a good range of Lee colour compensating and colour balancing filters with me, whenever I am shooting on location.

- ⊕ Andreas Von Einsiedel
- ⊜ Editorial
- ◉ Magazine
- ⊞ Hasselblad
- ◉ 50mm
- ⊡ Kodak EPP
- ⊘ 1/2 sec @ f/11
- ◔ Daylight and flash

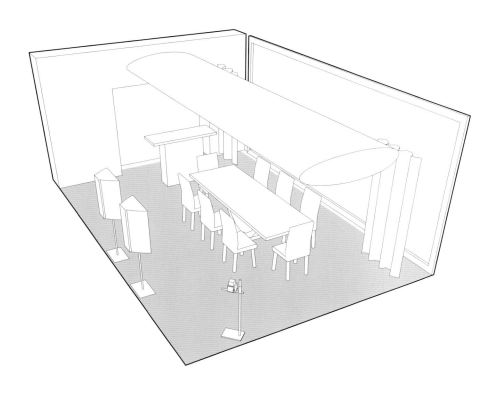

baggy house devon, uk

This house featured a picture window which could be lowered into the ground – a boon for photographers seeking to avoid reflections!

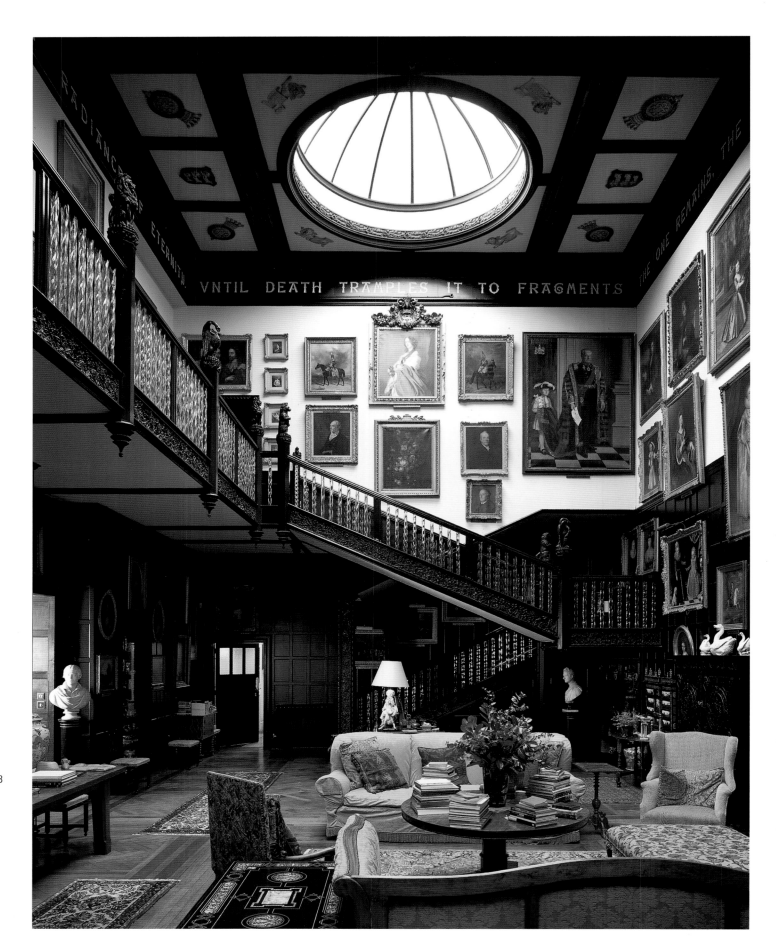

Although this shot is lit mainly with daylight, I also had to use multiple electronic flash. I took a Polaroid of the room from the same position that you see here. The daylight coming in through the roof was very even and lit most of the room including, surprisingly, the detail in the ceiling. However there were areas, such as the heavy wooden staircase, that needed more light.

To the left is a doorway with a bust just on its outside. In this doorway, I positioned two Elinchrom heads with honeycombs. One of these was directed at the balustrades of the first set of stairs and gave just the right light to pick out the detail. The second head was directed at the rear panelling of the room, which being very dark, needed all the light it could get if it was to record any detail at all. Another flash unit was placed in the room that is just visible in the far corner, with its door ajar. This helped to create depth and lifted the heaviness of the panelling. Finally another head, fitted with a grid, was placed just behind the camera to give some detail to the rear of the sofa in the foreground. This one was sync'd to the camera while the other units were fired by slave units, and each one was fired twice.

⊛ Jan Baldwin
⊛ Editorial
⊛ Book
⊛ Sinar P 5x4
⊛ 75mm
⊛ Fuji Provia 100
⊛ 10 secs @ f22
⊛ Daylight and flash

country house uk

The dark wood panelling in this shot required a lot of extra light to balance it with the rest of the room.

This was shot in a 19th century town house in Aleppo, Syria, where the light – when the sun shines – is intense and bright. The houses are built to retain coolness, as outside temperatures in summer exceed 38 C during the day. Walls are thick and windows face into courtyards, or are north facing, to keep temperatures tolerable. Rooms are often quite dark, so although this looks like a fairly standard daylight picture I had to use flash.

I used 3 heads of an Elinchrom 1500 pack, although the key was to make the shot look as if it was only lit by the daylight coming in through the windows. I also needed to retain the detail in the coloured glass at the top of these windows. If I had relied solely on daylight, this colour would have been burnt out. I bounced one head off the ceiling and another off the wall to my left, so that the reflection in the mirror would not appear to look 'dead'. Another head, on very low power, was directed toward the table and chairs

Tim Beddow
Editorial
Book
Mamiya RB67
65mm
Kodak EPP
2 secs @ f/16
Daylight and flash

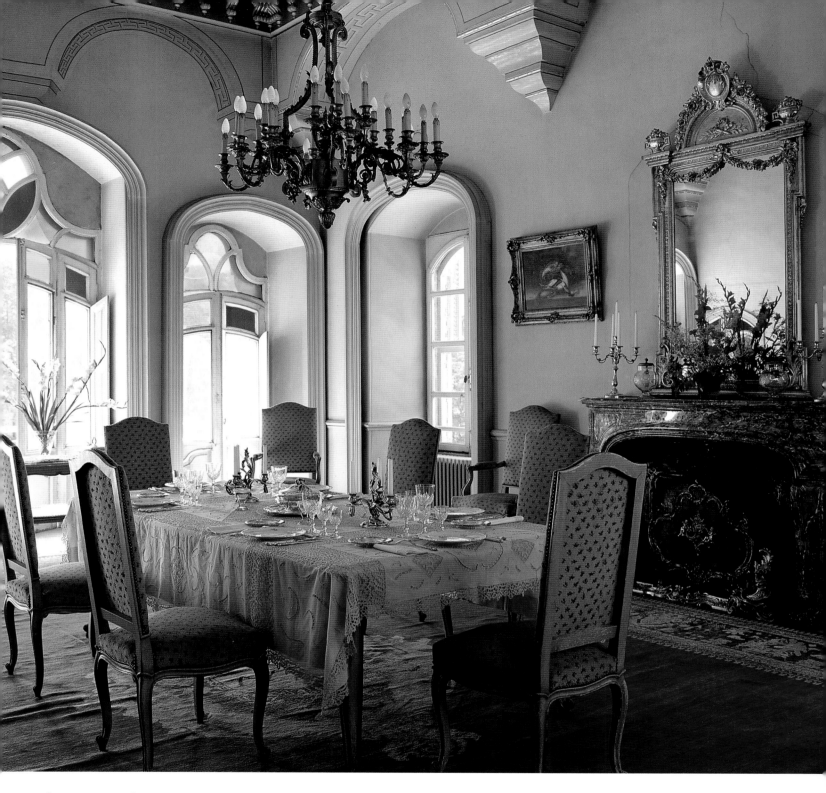

house aleppo syria

This room required three, subtly placed flash heads to light it – despite the brightness of the light outside.

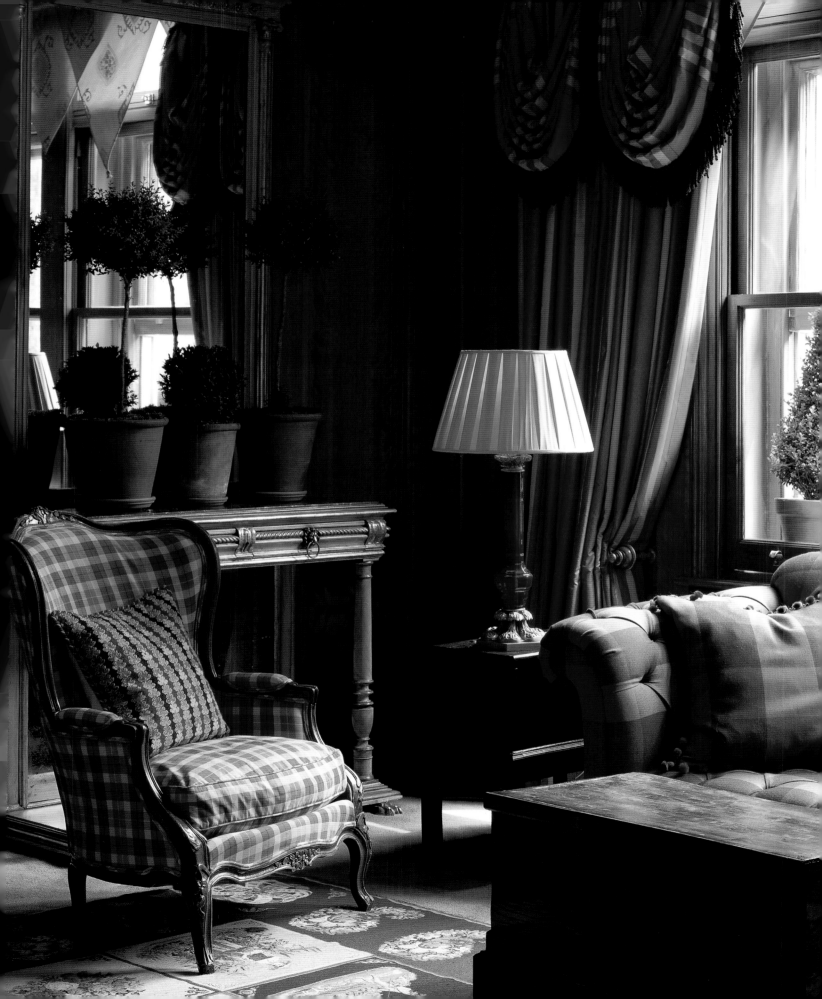

This shot needed fill-in flash but I wanted to make sure that I did not lose the feeling of a quite, intimate corner in this London hotel. Having styled the room to my liking (which involved moving the chair slightly and adjusting the position of the chest), I set about lighting it.

Having ascertained the exposure for the daylight (making sure that I did not burn out the curtain headings), I positioned one flashhead fitted with a softbox, to the left of the camera and gave it just enough power to record the detail in the arm of the chair and the chest. A further reflector was positioned to the right of the camera to bounce back a little more light into the side of the chest. The mirror on the left acted as a reflector and gave just enough fill to light the corner of the room. The final result is that the room looks as though it is just lit with the daylight coming in through the window.

Ⓐ Jan Baldwin
Ⓒ Advertising
Ⓒ Promotional book
Ⓒ Sinar P 5x4
Ⓒ 210mm
Ⓒ Fuji Provia 100
Ⓒ 2 secs @ f/16
Ⓒ Daylight and flash

covent garden hotel london, uk

The photographer adjusted the position of the furniture in this room to enhance the composition of the photograph.

I chose this viewpoint because I thought that it showed these remarkable sculptures, made of industrial plastic, to the best effect. Fortunately, there was a mezzanine floor which enabled me to be at the right height and to lean over to get the best angle. I had an idea of what the apartment looked like as I had seen some shots that a friend of mine, who lived in Milan, had done.

My main light source was daylight that came into the room from three large windows. These were located behind the unusual, hand-shaped chair at the top of the picture. I then placed an HMI light, fitted with a softbox, to the left of the shot to act as a fill. I used a 180mm lens, which has the effect of slightly compressing the perspective. Finally, I decided that it would be advantageous if the owner's dog was in the picture. As it was not willing to stay by itself I got my assistant to be in the picture with it. The overall effect is of a bright apartment with an intriguing perspective and a touch of human interest.

- Jan Baldwin
- Editorial
- Magazine
- Hasselblad
- 180mm
- Fuji Provia 100
- 1/30 sec @ f/11
- Daylight and HMI lighting

124 **apartment** milan, italy

Shooting from unusual perspectives creates images with strong visual impact.

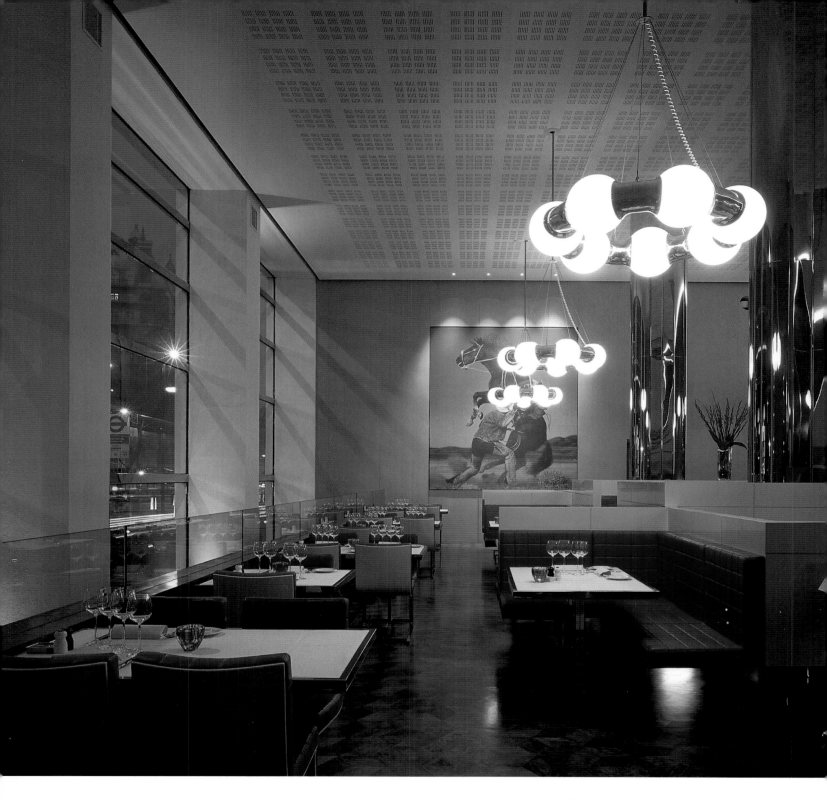

This London restaurant was photographed both during the day and in the evening. In the daytime (inset), the sunlight reflected from a glazed building opposite threw softened light into the north-facing windows, filling this part of the interior and overriding the effect of the artificial light. It was bright enough to produce a short exposure so that people could be included in the photo with only minimum blurred movement.

At dusk, the artificial lights illuminate the space as daylight recedes, producing a different atmosphere (main image). The lamps were tungsten but the shades were green, so I had to use filters on the camera to compensate for this. Movement, if any, in the restaurant had to be kept to an absolute minimum because of the long exposure. The lamps burnt out, but since they were lighting the space this had to be accepted. Perhaps under other circumstances, additional lighting could've been added which would've reduced this burning out, but with staff going about their usual business, this was an impractical proposition.

- Nicholas Kane
- Corporate
- Promotional
- Mamyia RB 67
- 65mm, 20 magenta filter
- Fuji 64 T transparency film
- 20 secs @ f/22
- Tungsten

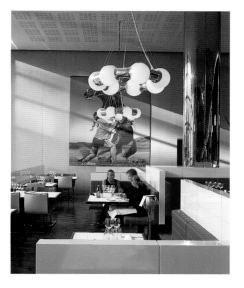

isola restaurant london, uk

The ambience of a place can change dramatically depending on the time of day at which it is viewed.

When I took this shot, I wanted to retain the warmth and intimacy that the room portrayed. Rather than just direct flash straight into it from the camera viewpoint, I positioned my main light to the right of the camera, behind the chair that can be seen on the right of the fireplace. Another light was placed to the left of the bed, directed to the alcove on the other side of the fire. Finally, a very low powered head, fitted with a softbox, was directed toward the curtain hanging from the four poster bed in the foreground of the shot. This had to be positioned in such a way that the folds of the material didn't get lost in a blast of direct flash.

The room lights were turned on and a Polaroid was taken to see what exposure was required to balance them with the flash. Having obtained this balance right to reflect the ambience of the room, the fire was lit and the shot was taken. In the resulting image it appears as though the room is lit only by the lights on the mantelpiece, the table lamp at the left of the picture and by the fire.

- Andreas Von Einsiedel
- Editorial
- Magazine
- Hasselblad
- 50mm
- Kodak EPP
- 3 secs @ f/11
- Mixed lighting

millais oxfordshire, uk

The lighting and exposure for this picture had to be adjusted in order to record the flames in the fireplace.

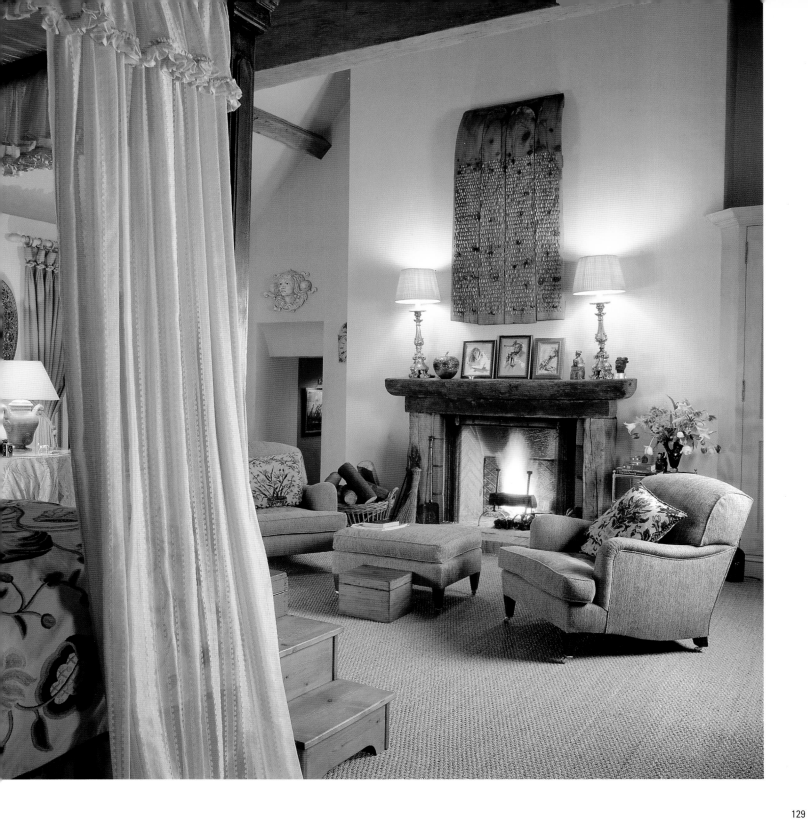

When I am doing a magazine shoot, it is often the detail rather than the 'big view' that creates the best shot. In this case it was the window blinds that had to predominate. It was a difficult day weather-wise, when we started the shoot, with either the rain pouring down or the sun bursting through the window. I chose to distance myself from the subject by fitting a 250mm lens to my Mamiya. This helped to compress the shot and, combined with a large aperture of f/5.6, the unattractive view through the window became anonymous. I lit the inside of the room with a single Broncolor head and softbox directed at the table, but making sure that it did not reflect in the window or create a highlight. By waiting for the rain to stop and the sun to come out, the final shot looked bright and sun-drenched. Slightly overexposing the daylight helped to enhance this sunlit effect and also hid the drizzle on the window panes.

- 🚶 John Freeman
- 🧭 Editorial
- 🌐 Book
- 📷 Mamiya RZ67
- ⚫ 250mm
- ▶ Kodak 100VS
- ⏱ 1 sec @ f/5.6
- 💡 Daylight and flash

130

dining table bristol, uk

Slightly overexposing the daylight has helped hide the ugly view through the window and disguise the raindrops on the window panes.

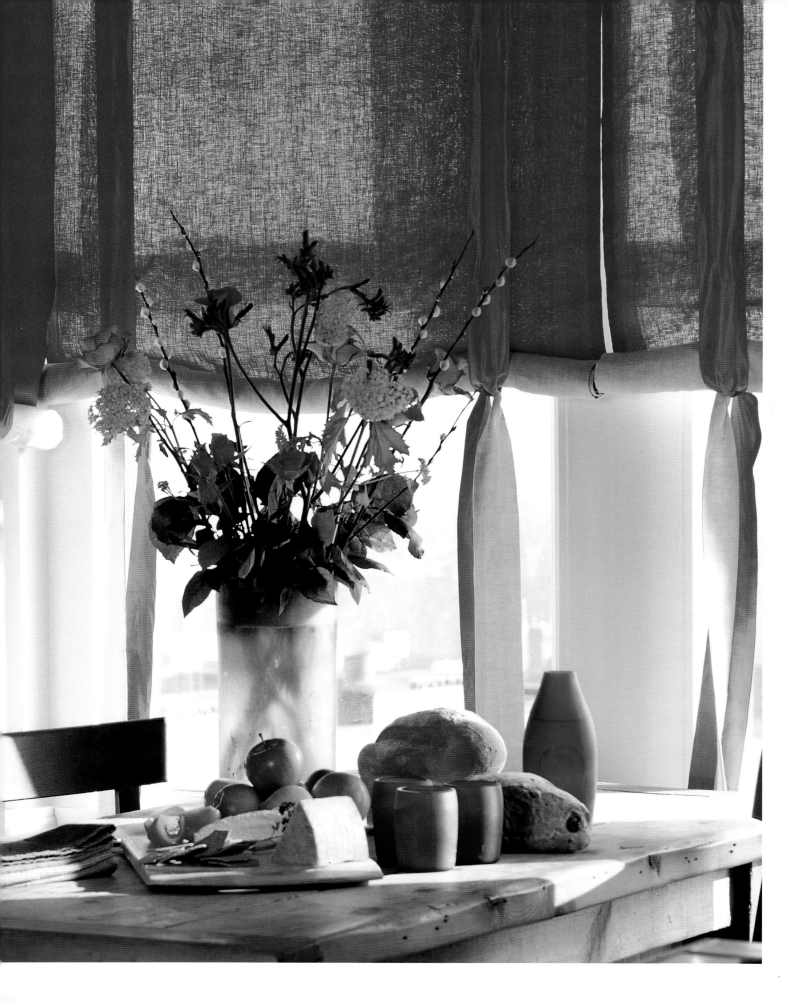

multiple light sources

I like to think that this is a good example of a mixed lighting shot where all the elements balance. First, we have the daylight coming in through the windows. Then there are these enormous chandeliers, four of which appear in the picture. And then there is just enough flash to fill in those unilluminated areas. The arches of the church make a perfect framing device as well as adding depth to the overall composition. It may look like this picture is lit with just the light you see and nothing else. However, as we know, film does not record a scene in the same way that we see it.

To begin with the windows only needed so much exposure, as did the chandeliers. Two Broncolor heads were positioned off to the left of the camera pointing into the church. Another smaller head was directed at the arch in the foreground. The ambient light reading was 12 seconds at F22. The soft box on the extreme left was fired 6 times and the one next to it 4 times while the one pointed at the main arch just twice. The camera was set to 2 seconds at F22.

⊛ John Freeman
⊝ Editorial
◉ Book
⊛ Sinar P 5x4
◍ 90mm
⊳ Kodak EPP
⊘ 12 secs @ f/22
⊙ Daylight, tungsten and flash

134 ## saint pimen church moscow

In this shot the flash heads had to be carefully hidden behind pillars to avoid them appearing in the frame.

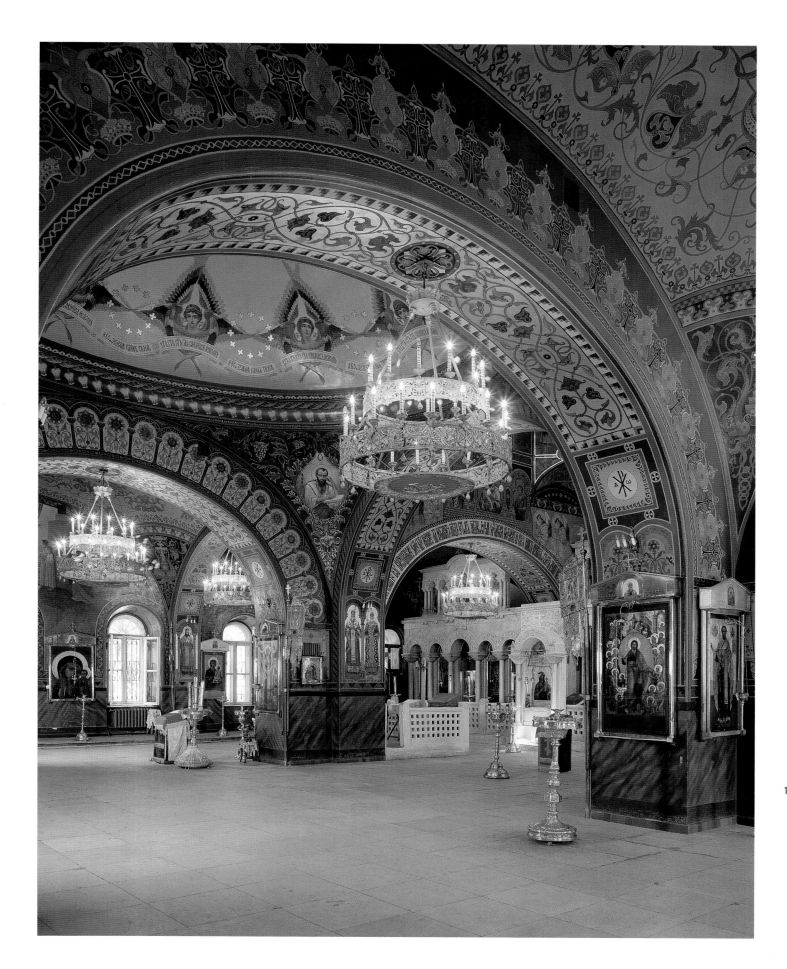

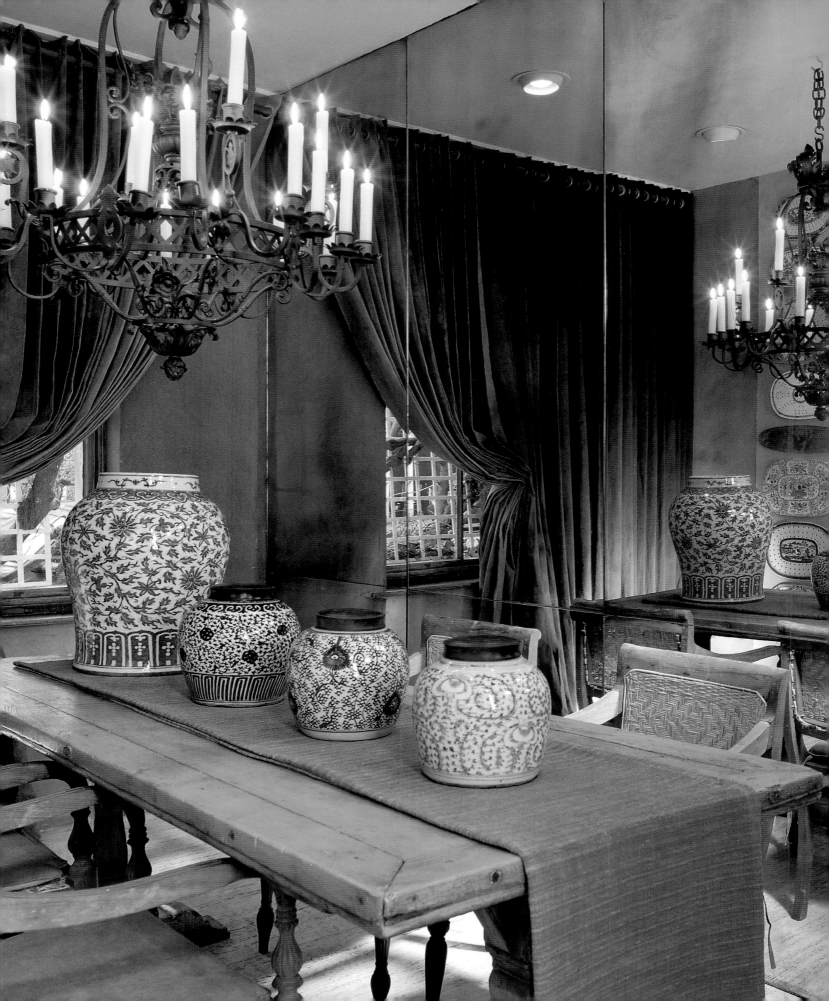

The difficulty with this shot was the wall of mirrors facing the camera. I had to select a viewpoint which ensured that neither myself, my camera nor the lights reflected in the mirror appeared in the shot. I positioned one Broncolor Primo pack as far to my left as I could, without it reflecting. Another was placed under the chair to the extreme left to give some detail in the curtains. But perhaps the most important light was the one that pointed away from the camera. This had to light the wall that was reflected in the mirror, yet be strategically positioned so as not to appear in the shot. If this wall had not been lit then the mirror wall would have been underexposed. The end result is that the room is evenly lit without being flat.

Andreas Von Einsiedel
Editorial
Book
Hasselblad
50mm
Kodak EPP
2 secs @ f/11
Daylight, tungsten and flash

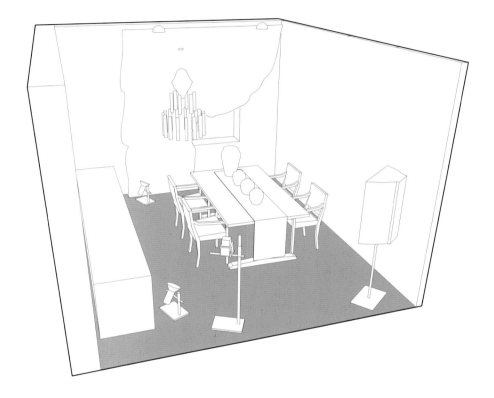

guinevere showrooms london, uk

The mirrored wall was the biggest headache facing the photographer in this shot.

This was quite a complicated mix of lighting and I needed to work quickly. I placed one Elinchrom head fitted with a snoot into the room to the left and directed it to give some highlights on what was a very dark bookcase. I placed another Elinchrom with an umbrella also in the doorway and directed it to the bottom of the bookcase. I took a reading of the daylight coming in through the window to the right of the picture and adjusted the exposure to balance it to the flash. I then lit the candles and the result is a stylish mix of lighting.

Fritz von der Schulenburg

Editorial

Book

Hasselblad

60 mm

Kodak EPP

4 secs @ f/16

Daylight, flash and candlelight

138

nureyev's apartment paris, france

This apparently simple interior was lit by a mixture of flash, daylight and candlelight.

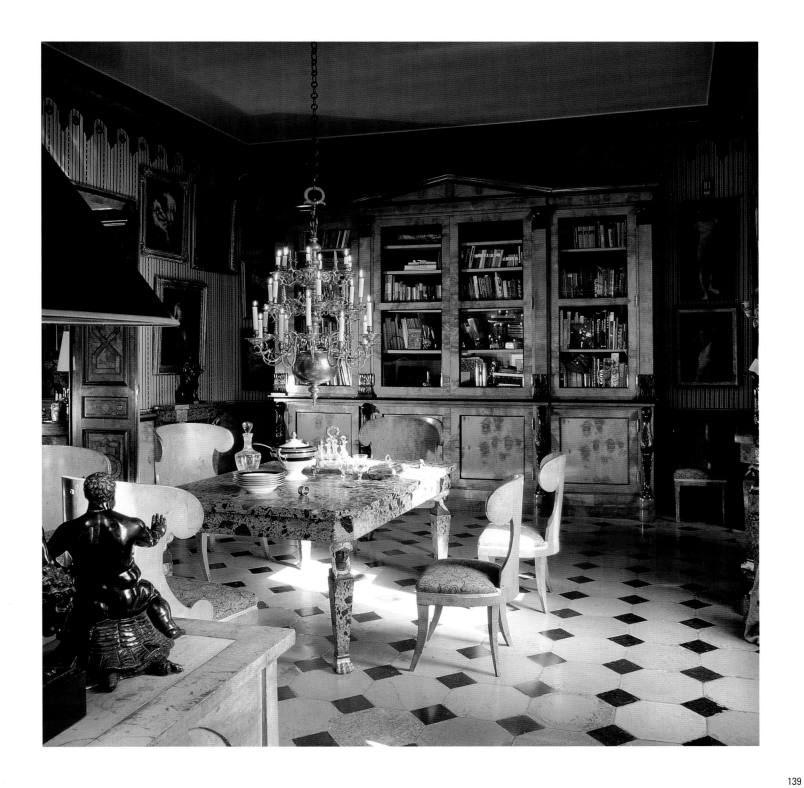

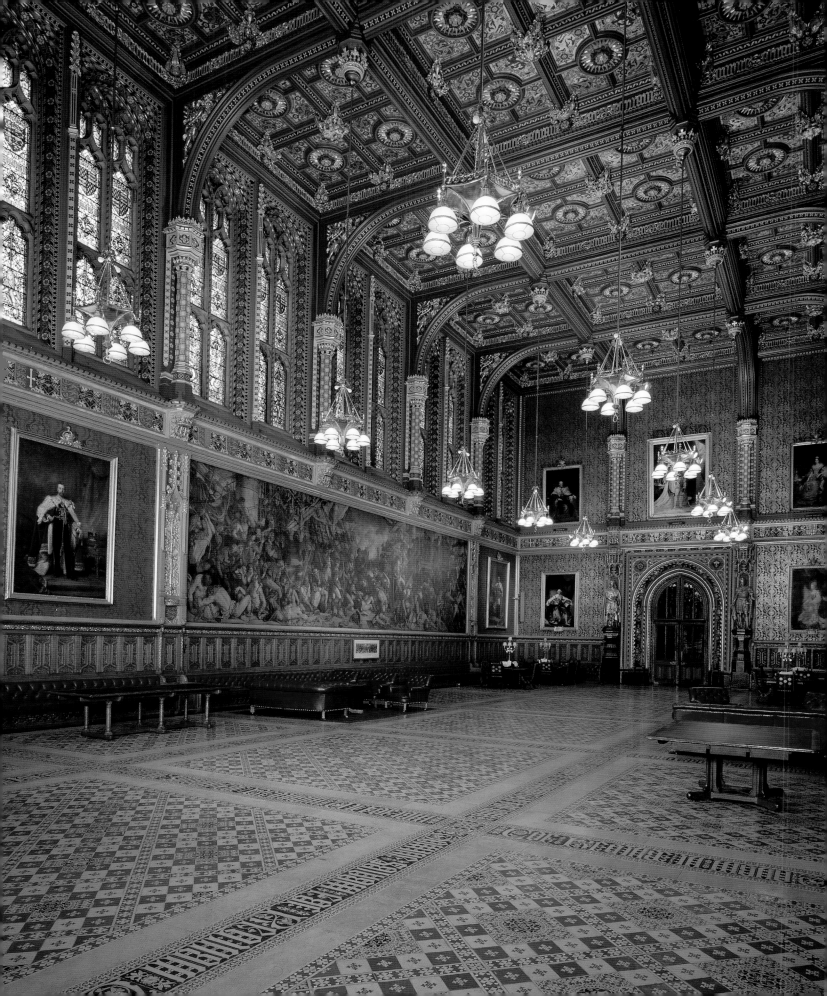

Rooms of this size need lots of light. If I had relied solely upon daylight, the windows would have been burnt out and none of their detail would have been recorded. The same would have been true if I had lit the room with the tungsten lights suspended from the ceiling. In this case, the ceiling lights would have been burnt out as well as the windows and there was always the possibility that there would have been a blue cast caused by the daylight, as I would have had to shoot on tungsten balanced film. I wanted the room to look as natural as possible and the only way I could achieve this was to add flash. Lots of it!

I used four Broncolor Pulso 8 packs and four heads with softboxes. I positioned two lights to the left of the camera, one pointing up to the ceiling and the other pointing straight ahead. I positioned another behind the camera pointing up to the ceiling and another to my right pointing straight ahead. Because it was not possible to take an accurate meter reading, I made a calculated guess at the exposure using the experience I had gained from similar situations. Each pack was programmed to fire 20 consecutive flashes – 80 in all. These had to be staggered so as not to overload the power supply. This meant a total exposure of 200 seconds; the time it took each pack to fire and recharge 20 times. I calculated the f stop at 22. After each pack had been fired 5 times, I switched off the room lights so that they did not burn out and appear on film as big white patches.

- John Freeman
- Editorial
- Book
- Sinar P 5x4
- 90mm
- Kodak EPP
- 200 secs @ f/22
- Daylight, tungsten and flash

the house of lords london, uk

It required 80 separate bursts of flash and a 200 second exposure to light this enormous room.

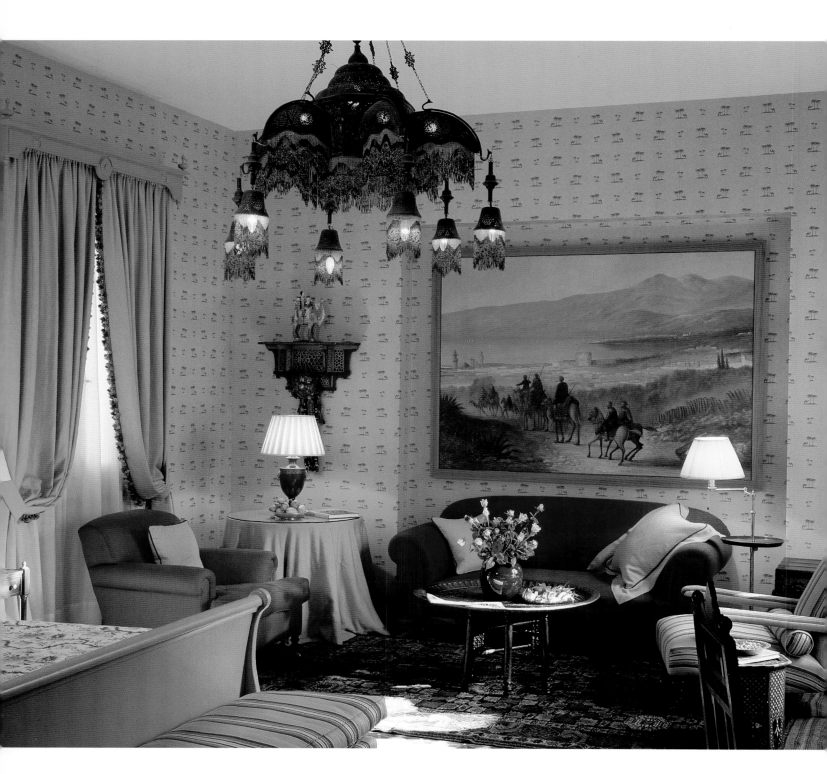

This is one of the individual bedroom suites in this fine hotel. The look of the room was exotic and warm and I thought it important to leave the lights on for a short duration to retain the ambience. To have turned them off would have created a cold feel to the shot. The building is situated in a residential part of the city, surrounded by other buildings, so it was important to pick the right time of day when any available light entered the room.

In addition to the window on the left, there were French doors on the right where I placed a large reflector. It was also necessary to have some fill-in flash, and I placed one Elinchrom head to the right side of the camera and bounced it gently off the ceiling. Having worked out the exposure for the daylight and the flash, I turned the tungsten lights off after 1 second to stop the room going too yellow.

Tim Beddow
Advertising
Brochure
Mamiya RB 67
90mm
Kodak EPP 120
3 Secs @ F16
Daylight, flash and tungsten

al bergo hotel beirut

The natural ambience of this hotel room was given a gentle boost thanks to a carefully placed flash head and a reflector.

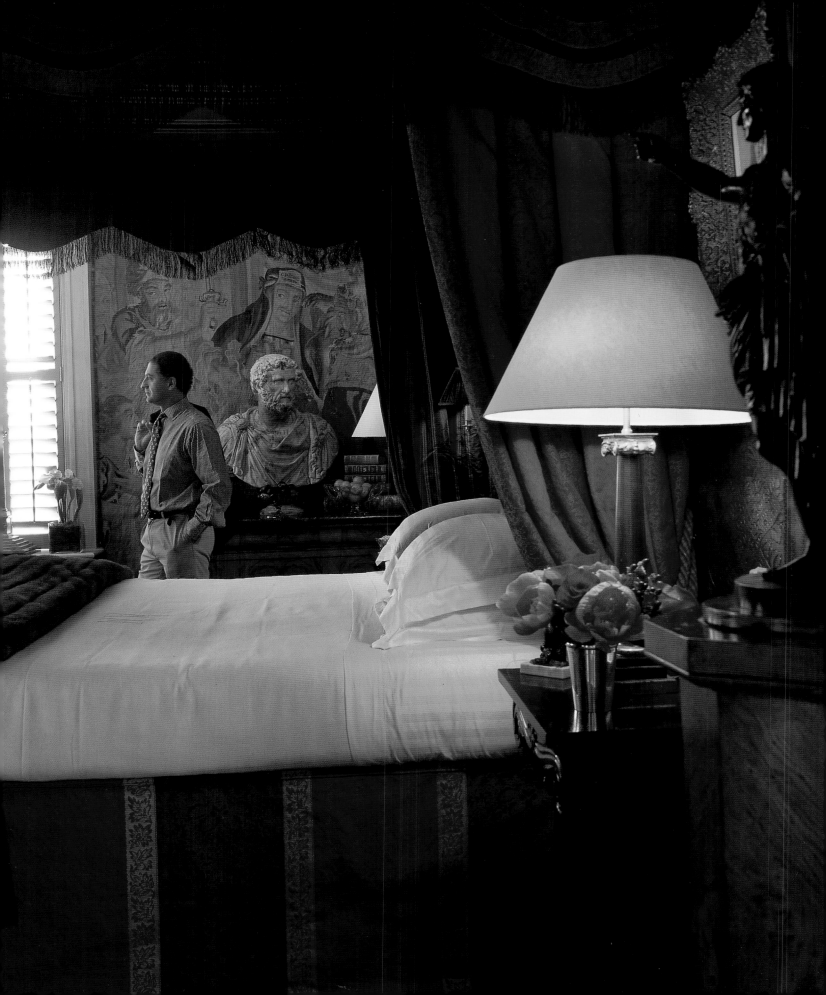

The interior design was all about mood and atmosphere, quite dark and clubbish. Because of this, I decided to mix the light source, daylight, fill-in flash and tungsten. The tungsten of the room's lights spills a warmth over the foreground of the picture. This is corrected a little with electronic flash, so that it doesn't go too warm and orange. The mid-ground and key area of information is lit by flash units but supplemented by bounced daylight, using reflector dishes. The window here is all important as it is the justification for the mood and colour of the light, so I allowed it to burn out a bit in order for it to look real, as if it were lighting the mid-ground.

(Ⓐ) Simon Upton
(☉) Editorial
(◉) Magazine
(▦) Mamiya RB67
(◉) 75 mm
(▣) Fuji RDP II
(☉) 1 sec @ f/11
(♡) Flash, daylight and tungsten

alidad interior london, uk

The warm mood of this image owes much to the light which was allowed to spill from the prominently placed table lamp.

Sometimes when balancing lights from different sources, it is necessary to build up the exposure, as is the case here. The hallway was quite dark, with just two windows, one on the upper floor and one on the lower. The only other illumination came from the two wall lights on the lower floor and the ceiling light on the upper floor. One Broncolor Pulso 8 pack was positioned just to the left of the camera and another was placed under the stairs on the lower floor. We needed to stop down to f/22 to make sure that everything was sharp and this meant that 8 full power flashes of 6,400 joules were required from both packs. However, because we were having to use a slow recycling time for the packs, 10 seconds on each one, this would have amounted to an overall exposure of 80 seconds. This would have resulted in the areas around the windows being completely burnt out. Having decided that an acceptable exposure for these areas would be 16 seconds at f/22, we divided that time by the number of flashes required. This was 2 seconds. Therefore, the exposure became simply a matter of taking 8 exposures of 2 seconds each at f/22. The ceiling and wall lights were switched off after 4 exposures so that they did not burn out.

John Freeman
Editorial
Book
Sinar P 5x4
90mm
Kodak EPP
16 secs @ f/22
Daylight, tungsten and flash

146 **the french embassy** moscow, russia

This opulent interior was lit by eight separate two-second exposures.

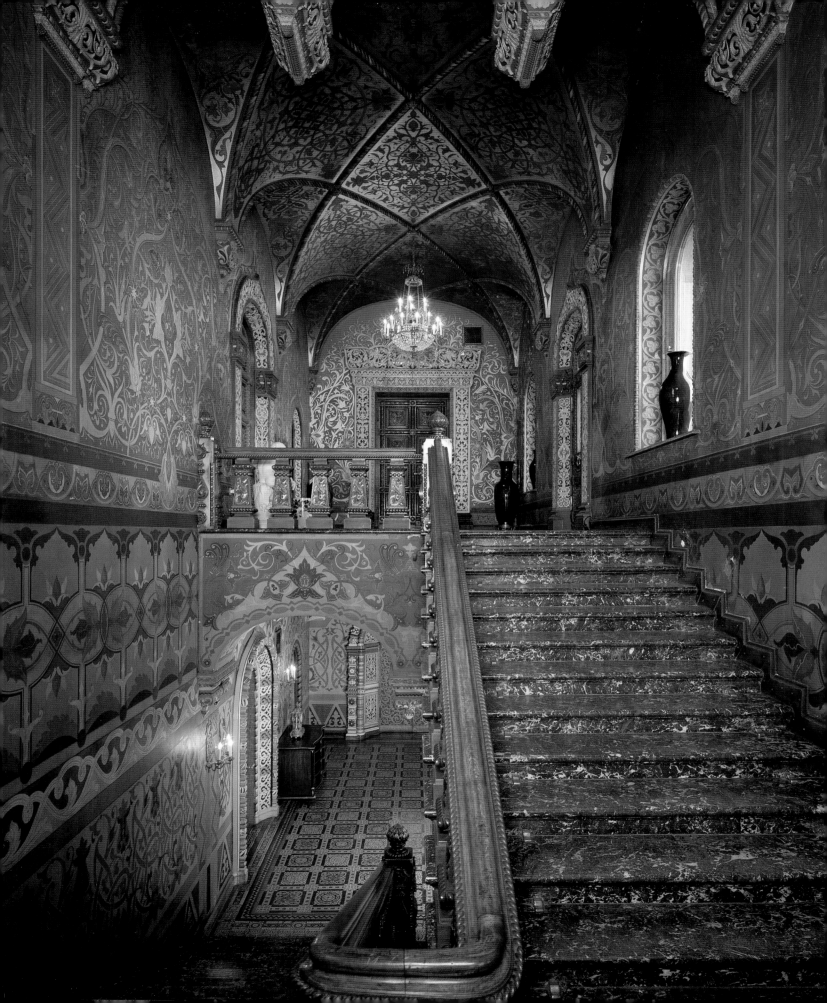

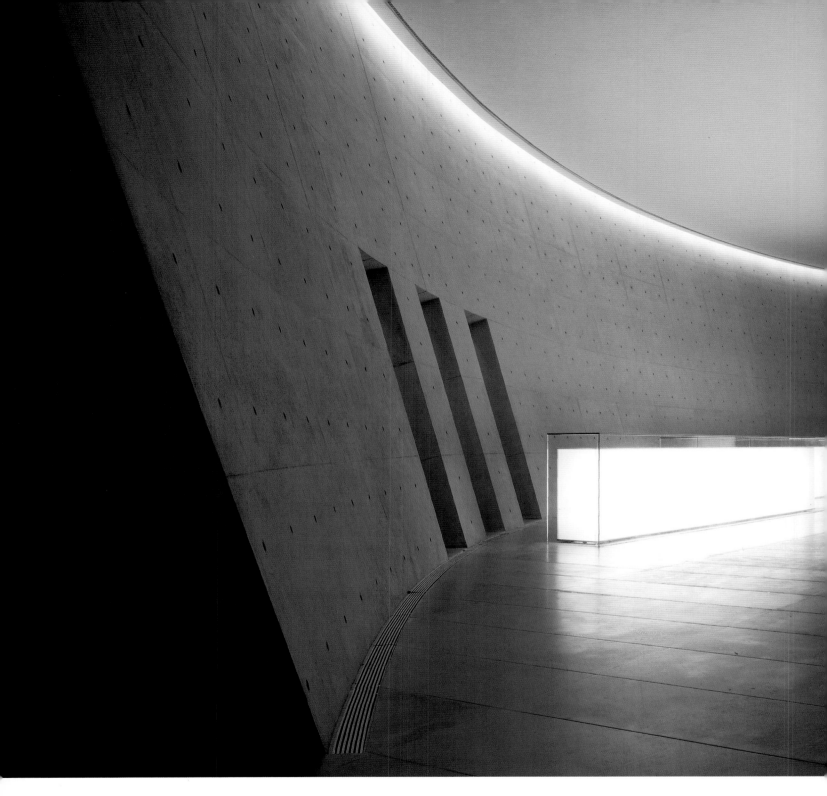

teatro armani milan, italy

Minimalist interiors with neutral tones can cause problems for the photographer as they draw attention to any colour cast.

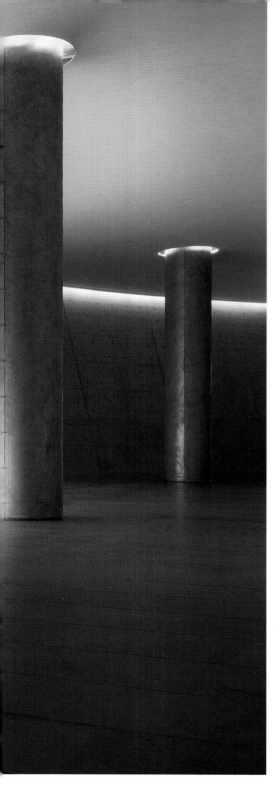

Minimal interiors pose particular problems for the
architectural photographer, not the least of which
is the importance of accurate colour rendition. In
this case, the neutral grey of the concrete was lit
by fluorescent light and daylight in the foreground.
I therefore filtered on camera for the fluorescent
and used fill-in flash, from two Elinchrom 1500
monoblocks gelled up to match the fluorescent.
This washed out the daylight in the foreground
and adjusted the colour to match the fluorescent.
The final exposure was made on daylight film, as
the recorded colour temperature was closer to
daylight than to tungsten.

- Richard Bryant
- Architect: Tadao Ando
- Editorial
- Linhof Technikardan 4x5
- 120mm Super Angulon, 10 magenta +82a filters
- Kodak Ektachrome EPN
- 22 secs @ f/32
- Daylight, fluorescent and flash

Many modern loft apartments have large wall to ceiling industrial windows that bathe the room in daylight. At night however, the mood can completely change with the use of ambient lighting.

To this effect, I photographed the apartment in daylight but then waited until night to do a few more shots. Working with the Mamiya, I composed the shot using a 180mm lens. This slightly compressed the view but helped to define the various layers of the room. I adjusted the ambient lights, by means of dimmer switches, to the intensity I required. To the naked eye, this gave a feeling of intimacy and warmth compared to the coolness and space of daylight. However, there were large areas of the room that were in deep shadow and which I knew would look unattractive on film.

I set up two Broncolor flash heads with softboxes, to which I had added gels to convert their colour temperature from daylight to tungsten to match the room lights. These were then positioned to throw light into the unlit areas and to balance them more closely to the room. The shot was taken using tungsten balanced film.

⚲	John Freeman
◒	Magazine
◉	Editorial
⬢	Mamiya RZ67
◎	180mm
◷	Kodak EPY
◷	4 secs @ f/22
◉	Tungsten and electronic flash

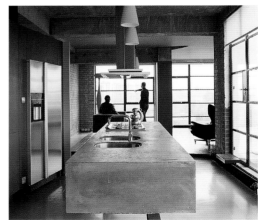

loft apartment london, uk

The contrast between these two shots shows how much the time of day you choose to work during, affects the ambience of a room.

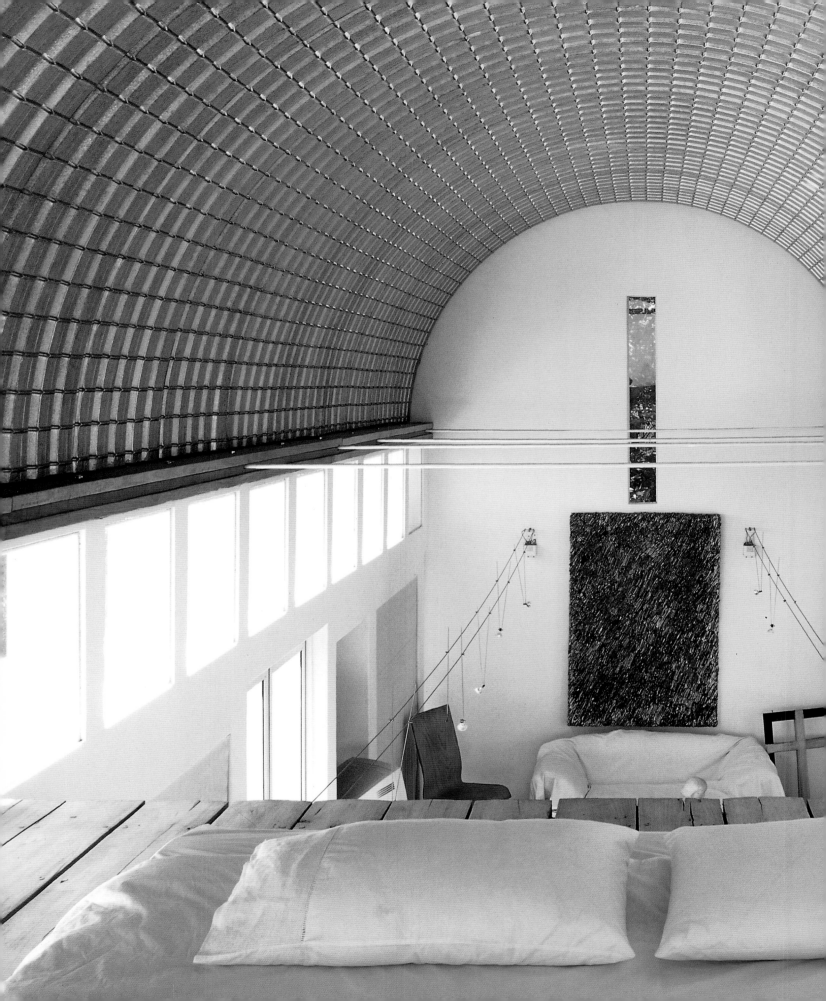

directory

photographer	Jan Baldwin
address	11 Gibraltar Walk
	London E2 7LH
telephone	+44 (0) 20 7729 2664
fax	+44 (0) 20 7729 3861
email	studio@janbaldwin.co.uk
wesite	www.janbaldwin.com

Jan Baldwin is one of Britain's leading food and interior photographers and her work appears regularly in World of Interiors, House & Gardens and leading national newspapers. She has travelled extensively throughout the world and has won awards for her landscape pictures.

photographer	Tim Beddow
mobile	+44 (0) 7767 348390
email	tbeddow@netcomuk.co.uk

Tim Beddow is an interiors photographer with a special interest in Africa and the Middle East. He spent a year documenting desert life with the writer Quentin Crewe for his book In Search of the Sahara, and subsequent book projects have included East Africa (Thames & Hudson) and Safari Style on the houses and lodges of East Africa. His most recent work, published in 2001, Damascus, Hidden Treasures of the Old City (Thames & Hudson), focuses on the beautiful but neglected courtyard palaces of the Old City.
He works for all the leading interior and design magazines.

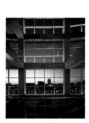

photographer	Richard Bryant
address	Arcaid
	The Factory
	2 Acre Road
	Kingston Upon Thames
	Surrey KT2 6EF
telephone	+44(0) 20 8546 4352
fax	+44(0) 20 8541 5230
email	arcaid@arcaid.co.uk
website	www.arcaid.co.uk

Since embarking upon an accidental career in architectural photography, Richard has interpreted the work of some of the finest architects and designers around the world. His work has been seen in leading international architectural and design publications as well as those devoted to primarily residential interiors.
His books include the study of Foster, Rogers and Stirling, companion to the Royal Academy Exhibition, The New Moderns, and Living Museums and he has produced, numerous monographs on a variety of projects worldwide. 2002 sees the publication of a book about another historic building close to Richard's heart, the Canova Museum by Carlo Scarpa in Possagno Italy.

Richard Bryant received the Daniel Katz Award for Architectural Photography and an honorary Fellowship of the Royal Institute of British Architects. Working alongside design agency Pentagram, a first class stamp was commissioned as part of the Millennium Series. Richard's subject was the Tate Modern, Bankside. It was released to correspond with the opening of the gallery. In Spring 2001, the stamp won him a silver award from the British Design and Art Directors (D & AD).

Richard Bryant together with his partner Lynne are founders of Arcaid Picture Library, which holds an international collection of photographs of the built environment.

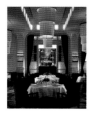

photographer Niall Clutton
address Arcaid
 The Factory
 2 Acre Road
 Kingston Upon Thames
 Surrey KT2 6EF
telephone +44(0) 20 8546 4352
fax +44(0) 20 8541 5230
email arcaid@arcaid.co.uk
website www.arcaid.co.uk

Niall Clutton has been shooting architectural interiors for twelve years. His work ranges from stately homes and castles to high tech museums and workspaces, as well as some of the best hotels and restaurants worldwide. He can be contacted by telephone on +44 (0) 20 8398 4527 or by e-mail at clutton@dircon.co.uk. Further examples of his work can be viewed at www.clutton.dircon.co.uk

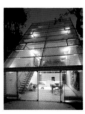

photographer Richard Davies
address 10 Steeles Road
 London NW3 4SE
telephone +44 (0) 20 7722 3032
fax +44 (0) 20 7483 1432
email richarddavies@easynet.co.uk

Richard Davies has established himself as one of England's leading architectural photographers. His work is regularly published in books, interior style and architectural magazines, both in the UK and abroad.

photographer Andreas von Einsiedel
address 72-80 Leather Lane
 London EC1N 7TR
telephone +44 (0) 20 7242 7674
fax +44 (0) 20 7831 3712
email andreas@einsiedel.com
website www.einsiedel.com

Andreas von Einsiedel is one of the world's leading interior photographers. His work is constantly featured in magazines and books both in the UK and throughout the world. Based in London, he runs an extensive library of interiors from around the world.

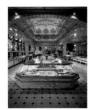

photographer	John Freeman
address	The Loft Studio
	Enterprise House
	59/65 Upper Ground
	London SE1 9PQ
telephone	+44 (0) 20 7827 9393
fax	+44 (0) 20 7827 9394
email	jfreeman@dircon.co.uk
website	www.johnfreeman-photographer.com

John Freeman is the author of several books on photography and interiors including London Revealed and Moscow Revealed. His work is constantly published in books and magazines both in the UK and abroad. He works from his studio in central London.

stylist	Amelia Saint George
address	Bastide des Arts
	1620 Chemin Barthelemy Vera
	13 290 Aix les Milles
	France
telephone	00 33 (0) 44 22 4 13 13
	or
address	28 Ormonde Gate
	London SW3 4HA
telephone	020 7349 8660
email	ASaintgeor@aol.com
website	www.ameliasaintgeorge.com

As well as being a successful stylist, Amelia Saint George is also the well known author of twelve books on decorative crafts including Provence, The Tradition of Craft and Design. She constantly works for publishers both in the UK and France, and regularly makes television appearances.

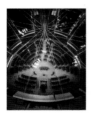

photographer	Dennis Gilbert
address	65 Twilley Street
	London SW18 4NU
telephone & fax	020 8870 9051

or for existing catalogue work:

address	VIEW Pictures Ltd
	14 the Dove Centre
	109 Bartholomew Rd
	London NW5 2BJ
telephone	020 7284 2928
fax	020 7284 3617
email	info@viewpictures.co.uk
website	www.viewpictures.co.uk

Dennis has been photographing buildings since 1980. After graduating as an engineer in South Africa, he travelled in South America and studied art in Los Angeles before moving to London in 1983. He has worked on projects such as Kansai Airport in Japan, Chek Lap Kok in Hong Kong, the German Parliament in Berlin, Reykjavik City Hall and Supreme Court, and the 12 new Jubilee Line stations in London. He is a founding partner in a London-based architectural picture library, VIEW (www.viewpictures.co.uk), which supplies pictures from many photographers to publishers worldwide.

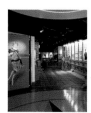

photographer	Martine Hamilton Knight
address	Arcaid
	The Factory
	2 Acre Road
	Kingston Upon Thames
	Surrey KT2 6EF
telephone	+44(0) 20 8546 4352
fax	+44(0) 20 8541 5230
email	arcaid@arcaid.co.uk
website	www.arcaid.co.uk

Martine Hamilton Knight is a well-known architectural photographer, whose company has been based in Nottingham since 1990. On graduation from the Surrey Institute with a first class honours degree, Martine started her business which now employs two other key people, who together run a successful photographic library and in-house darkroom.

Specialising solely in architectural photography, Martine travels nationwide for her clients (architects, interior designers, advertising agencies and magazines) photographing all aspects of architecture and interiors, including churches, restaurants, houses, offices, schools, factories, shops, civic and historical buildings. Published work can be regularly found in the Architects Journal, RIBA Journal and Architecture Today.

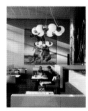

photographer	Nicholas Kane
address	Arcaid
	The Factory
	2 Acre Road
	Kingston Upon Thames
	Surrey KT2 6EF
telephone	+44(0) 20 8546 4352
fax	+44(0) 20 8541 5230
email	arcaid@arcaid.co.uk
website	www.arcaid.co.uk

Nicholas Kane continues to receive international recognition for what is now a decade of outstanding images created in the realms of architectural, interior, editorial, commercial, industrial and advertising photography. His photographs regularly appear in architectural, design and lifestyle magazines across Europe, North America and Japan. His work has been central to several books published by Mitchell Beazley.
This year Nick has also joined forces with award-winning installation-artist Alberto Duman for a permanent environmental sculpture at the South Bank Centre. He is regularly invited to participate in exhibitions around the world including the BBC Design Awards, Royal Institute of British Architects and the Museum of Contemporary Art in New York.

Recent commissions include Hamleys of Regent Street, Tommy Hilfiger's flagship store in New Bond Street, McCann-Erickson's new London HQ, a house on a private island in the Bahamas for Sotheby's New York, an innovative housing project in the Netherlands for Dutch architects MVRDV and Prime Minister Tony Blair's favourite building of 2001: the Tate Modern in London.

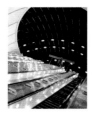

photographer	Hana Iijima
address	Arcaid
	The Factory
	2 Acre Road
	Kingston Upon Thames
	Surrey KT2 6EF
telephone	+44(0) 20 8546 4352
fax	+44(0) 20 8541 5230
email	arcaid@arcaid.co.uk
website	www.arcaid.co.uk

Hana is a relative newcomer to interior photography but has already met with great success. Her work has been published in numerous architectural magazines in the UK, Japan and Germany.

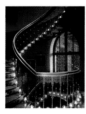

photographer	Fritz von der Schulenburg
address	The Interior Archive Limited
	6 Colville Mews
	Lonsdale Road
	London W11 2DA
telephone	+44 (0) 20 7221 9922
fax	+44 (0) 20 7221 9933
email	Karen@interior-archive.netkonect.co.uk
website	www.interiorarchive.com

For over 25 years Fritz von der Schulenburg has been photographing interiors for the world's leading interior magazines and books. His work can be seen regularly in The World of Interiors, House and Garden and Architectural Digest.

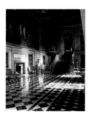

photographer	Simon Upton
address	The Interior Archive Limited
	6 Colville Mews
	Lonsdale Road
	London W11 2DA
telephone	+44 (0) 20 7221 9922
fax	+44 (0) 20 7221 9933
email	Karen@interior-archive.netkonect.co.uk
website	www.interiorarchive.com

Simon Upton is based in London but is commissioned to photograph interiors all over the world. His work features in all the leading interior magazines and books both here and abroad.

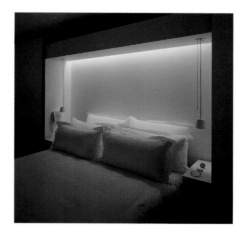

acknowledgements

I would like to thank the photographers whose work is featured in this book, for sharing their knowledge and contributing such amazing photographs. I would also like to thank Amelia Saint George for her participation in the project and my assistant Alex Dow for his help throughout. Finally, I would like to thank Nigel Atherton, Clara Théau-Laurent and Nicole Mendelsohn at Rotovision for their hard work and dedication.

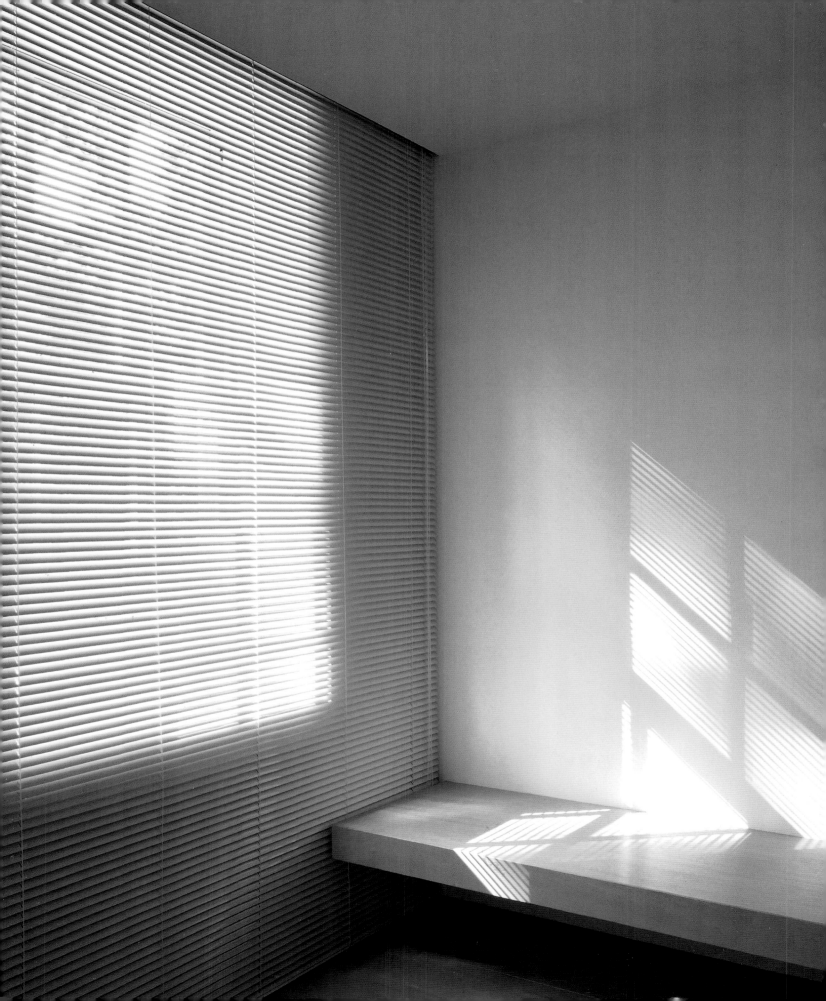